Leather and Fur

Leather and Fur
Aspects of Early Medieval Trade and Technology

Edited by
Esther Cameron

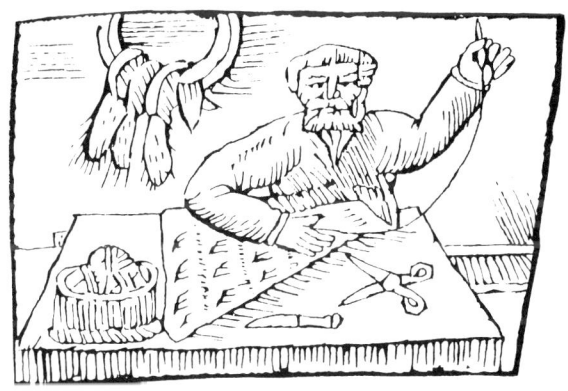

Archetype Publications
for the
Archaeological Leather Group

First published in 1998 by
Archetype Publications Ltd
6, Fitzroy Square
London W1P 6DX

© 1998: Copyright is held jointly amongst the authors,
and Archetype Publications.

ISBN 1 873132 51 4

All rights reserved. No part of this publication may be reproduced, stored
in a retrieval system, or transmitted, in any form or by any means, electronic,
mechanical, photocopying, recording or otherwise, without the prior
permission of the copyright holders.

Typeset by Kate Williams, London.
Printed and bound by Biddles Ltd., Guildford and King's Lynn.

Contents

	Contributors	vii
	Foreword	ix
1	Leather Working Processes *Roy Thomson*	1
2	Hides, Horns and Bones: Animals and Interdependent Industries in the Early Urban Context *Arthur MacGregor*	11
3	The Search for Anglo-Saxon Skin Garments and the Documentary Evidence *Gale R. Owen-Crocker*	27
4	Pre-conquest Leather on English Book-bindings, Arms and Armour, AD400–1100 *Esther Cameron*	45
5	The Leather Finds from Rouen and Saint-Denis, France *Véronique Montembault*	57
6	Trading in Fur, from Classical Antiquity to the Early Middle Ages *James Howard-Johnston*	65
7	Animal Bones from the Viking Town of Birka, Sweden *Bengt Wigh*	81
8	The British Beaver – Fur, Fact and Fantasy *James A. Spriggs*	91

Contributors

Esther Cameron Institute of Archaeology, 36 Beaumont Street, Oxford OX1 2PG.

James Howard-Johnston Modern History Faculty, Broad Street, Oxford, OX1 3BD.

Arthur MacGregor Ashmolean Museum, Beaumont Street, Oxford OX1 2PH.

Véronique Montembault 10 Grand Rue, 89500, Egriselles le Bocage, France.

Gale Owen-Crocker Department of English, University of Manchester, Oxford Road, Manchester M13 9PL.

James Spriggs York Archaeological Trust, Piccadilly, York YO1 1PL.

Roy Thomson Leather Conservation Centre, Nene College Campus, Boughton Green Road, Moulton Park, Northampton, NN2 7AN.

Bengt Wigh Birkagravningen, Box 5405, S-114 84 Stockholm, Sweden.

Foreword

This book is compiled from papers presented at a symposium entitled *Early Medieval Leather and Fur*, organised by the Archaeological Leather Group, which took place in Oxford in September 1995.

Interest in shoe styles and technology is well established in archaeological circles, largely for dating applications. Attempts to widen this interest to encompass the origins and development of the leather industry, the expansion and effects of trade in raw materials or goods relating to that industry, and hunting and furriers' trade, have been made difficult in the past by a scarcity of published evidence. The scope of the meeting was wide and drew on documentary and historical studies, archaeological and environmental evidence, studies in trade and economy, and reviews of object groups. As the day progressed it became apparent that susbstantial advances had been made and that this fresh information was worth publishing.

I thank all the speakers whose work is included here, as well as Chris Clarkson, Glynis Edwards, June Swann and Steve Webster, whose papers are not. Arthur MacGregor's paper, offered while this publication was in preparation, is included because it is so appropriate that it would have been hard not to. The opinions expressed in these pages are those of individual authors, and not those of the editor and the Archaeological Leather Group.

<div style="text-align: right;">Esther Cameron
May 1997</div>

◆1◆

Leather Working Processes

Roy Thomson

Leather can be defined as a material produced from the skin of any vertebrate animal, be it mammal, bird, fish or reptile by a process or series of processes that renders it non-putrescible under warm, moist conditions. It is generally considered to be softer and more flexible than a raw skin that has simply been dried out. However, leather can be hard or soft, stiff or supple, stretchy or rigid, or limp or springy depending on the raw material used and the processes employed in its manufacture. The skill of the tanner lies, as it always has, in being able to vary these attributes to produce a material with just the blend of properties required by the end user. A true leather will retain its properties, more or less, despite repeated wetting and drying. Other skin products such as rawhide, parchment or alum tawed pelts lose their resistance to putrefaction when exposed to moist conditions. But this defines leather according to its fundamental properties, and not by how these characteristics are achieved. To do this it is necessary to consider the nature of the skins themselves, the materials employed in the various pre-tanning, tanning and post-tanning operations and their interactions.

Skin is made up of three distinct layers: the *epidermis* together with the associated hair and hair root systems; the *dermis* or corium throughout which are embedded, among other things, blood vessels, fat cells, sweat glands and muscle; and finally the *subcutaneous* or flesh layer (Haines 1981; 1991a,b).

The epidermal layer consists primarily of dead keratin cells. Keratin is a protein containing a large quantity of the amino acid cystine. This amino acid incorporates a strong sulphur–sulphur bond in its molecular structure, which is responsible for the relatively high stability

of keratinous substances such as hair, wool, hoof, horn, claw, beak and feathers. This sulphur–sulphur bond is, however, broken under alkaline conditions and this property has been exploited by tanners in various unhairing operations from the earliest times.

The subcutaneous layer comprises a thin sheath of muscle fibres associated with a layer of fat cells. Generally these were removed mechanically prior to tannage.

It is only the main dermal or corium layer that is processed to form leather. This consists of a three dimensional network of fibre bundles embedded in a jelly-like 'ground substance'. These bundles are made up from strands of the protein collagen twisted round each other in a complex manner forming fibrils, fibres and finally the bundles themselves.

The protein collagen is characterised by a relatively high content of the ring-structured amino acids proline and hydroxyproline. These contribute fundamentally to the fact that collagen is a relatively long, thin, rigid, rod-like molecule made up from three similar chains wound

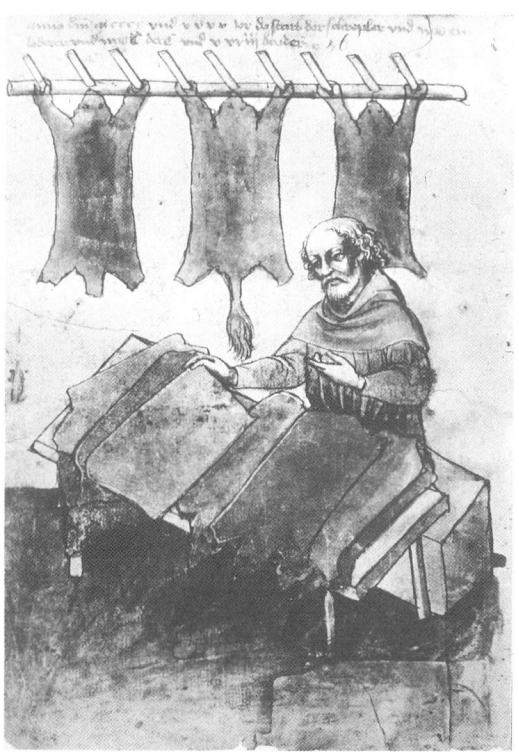

1. Tanner 1440, from Das Hausbuch der Mendelschen Zolf Bruderstiftung zu Nürnberg, *Munich (1965).*

around each other in a helical form. Short side chains stick out from the sides of this triple helix, many incorporating chemically active groups that react with complementary groups from adjacent helices stabilising the whole structure in a manner analogous to cross braces on scaffolding. When an animal dies these cross links are broken down by enzyme activated biochemical reactions and putrefaction sets in. In essence, tanning is the formation of replacement artificial cross links, resistant to such normal biochemical attack.

The 'ground substance' consists of a complex mixture of globular proteins and protein–polysaccharide complexes. It is necessary to remove the bulk of these materials before tanning to allow the tanning material to penetrate into the collagen network, where it can react efficiently. Failure to remove these complexes results in them sticking together as the leather dries out, leading to a stiff, cracky product.

Fur is produced from the skin of suitable mammals, treated in such a way that the hair remains firmly embedded in the skin, which itself is

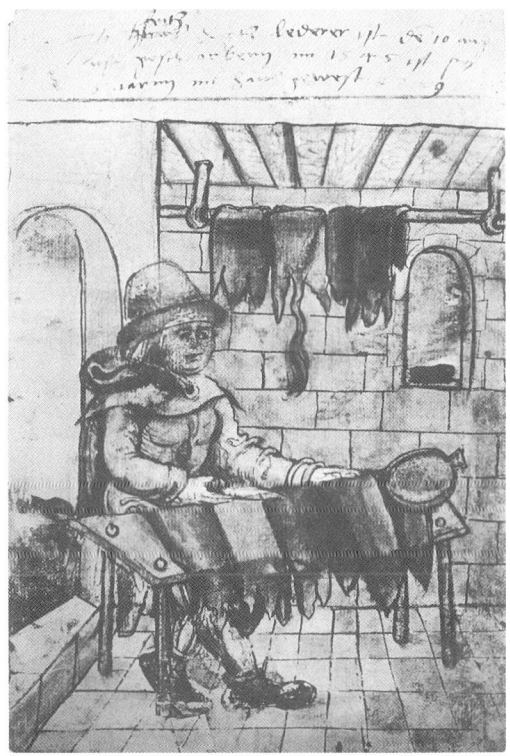

2. *Tanner 1545, from* Das Hausbuch der Mendelschen Zolf Bruderstiftung zu Nürnberg, *Munich (1965).*

rendered soft, flexible and resistant to putrefaction. However, it should be noted that, until recently, fur skins were not usually fully tanned, and their resistance to repeated wetting was variable. From depictions of objects made from leather and fur and from the amount of leather that has survived, it is obvious that skin processing industries were flourishing and widespread in England throughout the medieval period (Waterer 1946; Thomson 1981a). While manuscript illustrations show the use of skin products, there is little pictorial evidence of the processes involved in their manufacture. Definitive archaeological evidence is also sparse.

But just what were the processes used? The tanner, tawyer (or whittawyer as he was sometimes called), parchment maker or skinner would have obtained skins locally, fresh from the butcher, or from further afield in a salted or otherwise preserved condition. Hides and skins were traditionally sold with their hooves and horns still attached. These, with other appendages, would have been removed before processing. The skins would then have been washed to remove blood and dung. This

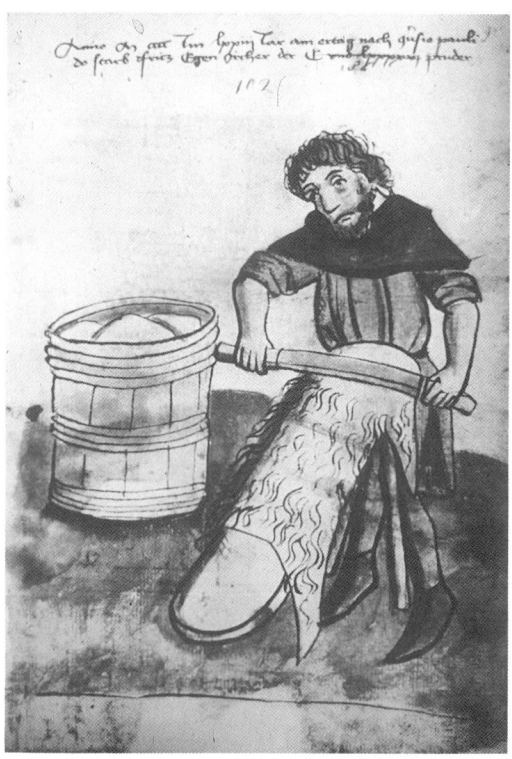

3. *Tawyer 1473, from* Das Hausbuch der Mendelschen Zolf Bruderstiftung zu Nürnberg, *Munich (1965).*

operation was often carried out in a nearby stream and disputes with neighbours over water pollution were not uncommon.

If the skins were to be used by tanners, tawyers or parchment makers, the hair or wool needed to be removed. This could be done in one of two ways. The first was to leave it until incipient putrefaction set in at the hair roots. The hair could then be plucked or pushed from the grain surface by hand. This method was favoured until the late nineteenth century for removing wool from sheep and lamb pelts. The alternative was to immerse the skins in pits or barrels containing strongly alkaline liquors. Wood ash could have been employed but a suspension of slaked lime appears to have been more common. Lime liquors were used over and over again and the by-products that accumulated improved the unhairing and pre-tanning actions. The alkaline conditions have two effects. The first is a breakdown of the sulphur–sulphur bonds, which weakens the keratinous structures, particularly at the epidermis/dermis interface, and allows the hair to be pushed off mechanically. The second

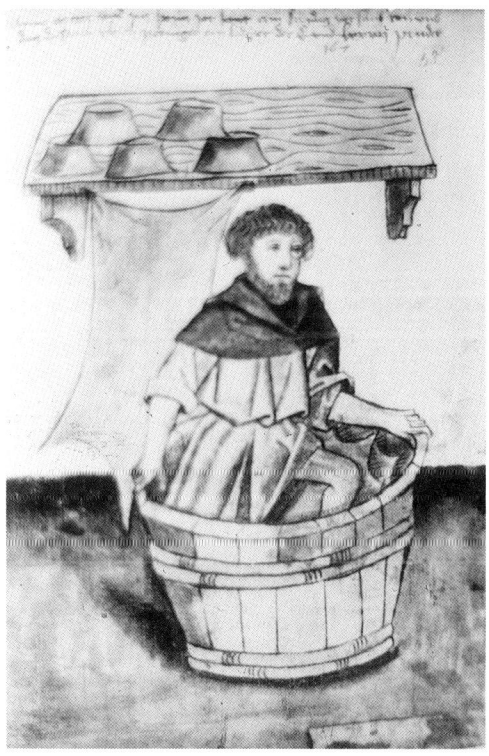

4. *Tanner 1464, from* Das Hausbuch der Mendelschen Zolf Bruderstiftung zu Nürnberg, *Munich (1965).*

effect is to break down the protein poly-saccharide complexes into soluble fractions that can be washed out of the skin structure. In addition to removing the hair or wool, any remaining flesh would have been cut and scraped off. Traditional two-handled knives, together with curved beams are depicted in drawings from the fifteenth century onwards. Similar knives are said to have been excavated at Pompeii. It has therefore been generally assumed that this type of tool was in continuous use throughout the medieval period but this has yet to be confirmed.

Parchment makers took the skins at this stage, after liming, and stretched them on frames using cords and pegs similar to those used to tune violins. The frames were stacked, either in sheds or in the open air, to allow the skins to dry. When the pelts were semi-dry, they were splashed with hot water to shrink the surface, partially treated with a paste of chalk or other earthy material to remove fat, and worked mechanically with special knives (Ruck 1991; de Hamel 1992). Pictures from the medieval period of parchment makers at work indicate that

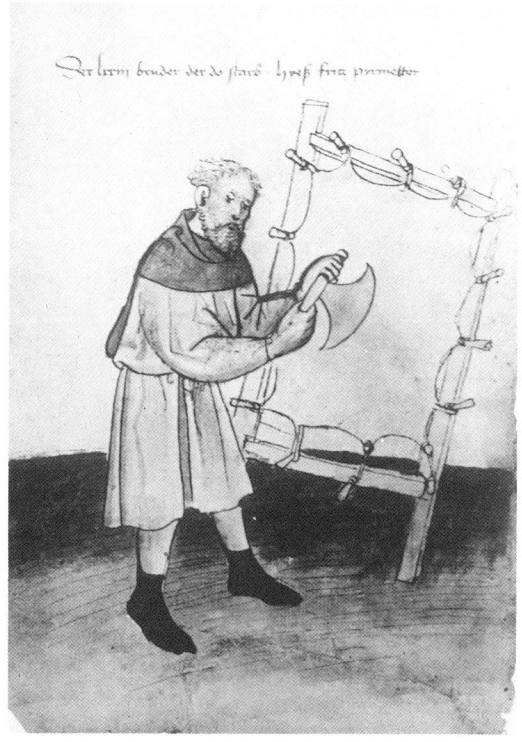

5. *Parchment maker 1425, from* Das Hausbuch der Mendelschen Zolf Bruderstiftung zu Nürnberg, *Munich (1965).*

these knives were similar to those still used today. It should be borne in mind that both parchment and leather could well have been made on the same premises by the same individuals.

By the late Middle Ages there are numerous references to the process of treating limed pelts with various biochemically active compounds. These acted on the partially degraded proteinacious materials, breaking them down further so that they could be removed mechanically. This gave a softer, more supple leather with a finer grain surface. The compounds used included dog, dove and pigeon dungs in the alkaline *bating*, puring or mastering process. Alternatively, fermenting vegetable materials such as barley were used in the acidic *raising* or *drenching* operations. These materials also neutralised the strong alkali present in the skin, enabling it to be treated with tanning materials. Only when these various pre-tanning processes, designed to clean up the skin structure, were completed could the tanning processes themselves be carried out. These can be divided into three groups, as follows.

The first involved treating the skin with various fatty materials. Brains and bone marrows had been used from Palaeolithic times and were still employed in North America and Asia until recent years. Train oil, a mixture of fish and whale oils, is referred to in the post medieval period. The action of these oils was complex. They coated the collagen fibres and prevented them from sticking together as the pelt dried. In addition, they formed a hydrophobic layer around the fibres, which prevented them from being rehydrated in wet conditions. Finally, if suitable oxidisable oils were employed, organic crosslinking agents were formed *in situ* giving a true tanning action similar to the chamois process of today.

The second process was to use a mixture of alum, salt and fatty material, such as egg yolk, to produce a fine, white, soft leather. However, most aluminium complexes that crosslink the collagen network are readily hydrated. As a result, alum tawed skins have little resistance to repeated wetting, and are therefore not true leathers. This was recognised in the Middle Ages by the fact that this operation was termed tawing or whittawing, rather than tanning.

The third and most important method was the vegetable tanning process, in which the skins were treated with aqueous infusions of various vegetable tanning materials. From the late medieval period until the beginning of the nineteenth century, the only material that could be employed legally for tanning cattle hides was oak bark (Thomson 1981b). However, other species including willow, ash, chestnut, pine, alder, spruce, larch and birch have been used in northern Europe. The active materials in all of these extracts are various high molecular weight

polyphenolic complexes. These penetrate the collagen network, forming multi-point hydrogen bonding links quite different from the chemical linkages found with the other classes of tanning process (Sykes 1991; Bickley 1991).

These three systems could have been used separately or in combination. It has been suggested, for example, that early cordwain leathers were processed using a mixture of alum and vegetable tannins. As time went on, however, the term *cordwain* became debased and was used to imply any fine leather. In the same way, the word *vellum* is used today to describe a higher quality of parchment (or paper) and all shoe-upper leathers produced from bovine stock are described as *calf* by sales assistants in shoe shops.

After tanning, the skins were dried and then shaved to a uniform thickness, treated with oils, fats and dyes, and worked mechanically. These operations were carried out by the currier rather than the tanner. Some evidence suggests that curriers in thirteenth-century London belonged to a different guild from that of other leather-workers. Elsewhere tanning and currying may have been carried out together. The currier's knife is depicted on the coat of arms of the Curriers' Company of the City of London, granted in the sixteenth century. It is not known when this implement was first introduced.

The processes carried out by the skinners, as fur-skin producers and traders were known, were similar but with differences in detail (Veale 1956). Instead of liming, which was designed mainly to degrade keratin and remove the hair and epidermis, the skins were subjected to a series of washing treatments. Care had to be taken to ensure a thorough cleaning and rehydration of the collagen fibres while at the same time avoiding putrefaction. The flesh was carefully removed during these operations. Oil, alum and vegetable tannages were all used. However, the problem for the skinner was that as he achieved a more efficient tannage, the pelt became tighter and less stretchy and lacked the 'run' desired by the garment maker. This is the ability of a lightly tanned skin to stretch in one direction while remaining relatively elastic at right angles to this. There was also a danger of the tanning materials affecting the quality and lustre of the fur. For this reason, what became known in the nineteenth century as *Leipzig Dressing* was developed. In this, the skin, after it had been thoroughly cleaned, was immersed in a bath of fermenting barley or other starchy material similar to that used by the tanner in the raising process. In addition to containing specific enzymes that broke down unwanted skin components, the ferment produced a mixture of organic acids that prevented damaging bacterial action and rendered the skin

stable. These acids could, however, be washed out, so the skins were susceptible to water damage. As with the tanners, skinners often used a mixture of methods depending on the type of raw material being worked and the result desired.

In this review I have aimed to give an outline of the manufacturing methods that could have been employed in the processing of skins in the early medieval period.

Bishop Aelfric, writing in the eleventh century, put the following words into the mouth of a Saxon shoewright (Waterer 1946):

> I buy hides and skins and I prepare them by my craft, and I make of them boots of varying kinds, ankle leathers, shoes, leather hose, bottles, bridle thongs, flasks and bougets, leather neck pieces, spur leathers, halters, bags and pouches and nobody would wish to go through the winter without my craft.

We could all add to Aelfric's list but none would disagree with his final sentiment.

References

Bickley, J. C. (1991) 'Vegetable tannins', in *Leather: Its Composition and Changes with Time*, C. Calnan and B. Haines (eds), Leather Conservation Centre, Northampton, 16-23.

de Hamel, C. (1992) *Scribes and Illuminators*, British Museum Press, London.

Haines, B. (1981) *The Fibre Structure of Leather*, Leather Conservation Centre, Northampton.

Haines, B. (1991a) 'Skin structure and leather properties', in *Leather: Its Composition and Changes with Time*, C. Calnan and B. Haines (eds), Leather Conservation Centre, Northampton, 1-4.

Haines, B. (1991b) 'The structure of collagen', in *Leather: its composition and changes with time*, C. Calnan and B. Haines (eds), Leather Conservation Centre, Northampton, 5-9.

Ruck, P. (ed.) (1991) *Pergament* (Historische Hilfswissenschaften vol 2), Sigmaringen.

Sykes, R. L. (1991) 'The principles of tanning', in *Leather: its composition and changes with time*, C. Calnan and B. Haines (eds), Leather Conservation Centre, Northampton, 10-11.

Thomson, R. (1981a) 'Tanning – Man's first manufacturing process?', *Transactions of the Newcomen Society* **53**, 139-56.

Thomson, R. (1981b) 'Leather manufacture in the Post Medieval period with special reference to Northamptonshire', *Post Medieval Archaeology* **15**, 161-75.

Veale, E. (1956) *The English Fur Trade in the Late Middle Ages*, Oxford.

Waterer, J. (1946) *Leather in Life, Art and Industry*, London.

◆2◆

Hides, Horns and Bones:
Animals and Interdependent Industries in the Early Urban Context

Arthur MacGregor

A dependable food supply might be posited as the single most fundamental condition for the development of urban society. As settlements grow in size, they inevitably draw into themselves an ever increasing volume of foodstuffs including – in the European context at least – quantities of animals which, until the development of refrigerated transport, arrived characteristically on the hoof. In addition to their food value, the carcasses of some of these animals also formed valuable sources of raw materials for the industries of my title: they provided hides, especially those derived from cattle and processed into leather; horns, particularly those of cattle but to a lesser extent also those of sheep and goats; and bones which, for reasons that will be explained, must be sub-divided straight away into skeletal bones and antlers, especially those derived from red deer.

A fundamental interdependence exists between urbanism, supply and demand for each of these industries. None of them depended on the emergence of urbanism for their initial development and in the case of antler in particular the rise of towns could be said to have had a negative impact as far as the industry dedicated to its use was concerned. In order to illustrate the effect of urban development, I will first outline the character of these industries as they existed in the early post-Roman centuries.

Artefacts of bone and antler appear as consistent elements in the material culture of all the native societies that reasserted themselves in central and northern Europe as the influence of Rome went into eclipse. Bone seems to have been the preferred material for a range of craft implements utilized, for example, in the production of textiles, the majority of them easily produced from food refuse with nothing more sophisticated than

a knife and no doubt manufactured by the end user as and when required (see MacGregor 1985: 185–93). Although these constitute perhaps the most numerous class of bone artefacts at this time, and despite a widespread uniformity of appearance, there is nothing here that would lead us to postulate an industry in the economic sense, but if we look at one of the other characteristic products of the period, the composite comb, a very different picture emerges.

Composite combs embody a higher level of skill in their production than is implied by the simple tools already mentioned. Their manufacture involves the production of a number of separate elements within a fairly narrow range of tolerance and with the aid of a specialized tool kit. Their comparatively complex method of construction displays an appreciation of the structural organization of the raw material and the consistent choice of antler rather than skeletal bone as the preferred material reveals an awareness of the mechanical superiority of antler, a characteristic that has been demonstrated scientifically only recently (MacGregor and Currey 1983). All of these factors lend support to the suggestion that the production of these items was already restricted to a defined body of manufacturers, and whether they are to be identified as, in some sense, professionals seems at least arguable. It has been suggested elsewhere (MacGregor 1989: 107–10; MacGregor 1991: 355–60) that the producers of these combs were indeed largely dedicated manufacturers who exploited a single raw material. In the era before the emergence of towns, no settled workshops are likely to have existed and producers would have carried their wares to consumers, found either in scattered communities within a given region or, perhaps more importantly, gathered together at periodic meetings concerned with the observation of religious or secular duties. Such an arrangement would have had the added advantage of allowing for the exchange of raw materials, since much of the antler utilized would not have come from slaughtered deer but would have been shed naturally in the wild (we shall return later to the evidence for this assertion) and would no doubt have been channelled to manufacturers by the country population at large.

The status of the horn industry at this time is less clear, largely due to the fact that horn survives only under the most favourable environmental conditions. Unlike antler, which is a deciduous outgrowth of bone, horn, composed of keratin, is both permanent and entirely organic: it is laid down around a boney core (the *os cornu*) in the form of a hollow cone, the last few inches only of the tip being solid. Investigation of the corroded tangs of iron knives from certain Anglo-Saxon graves has shown, however, that the majority had been hafted with horn, which

has simply not survived (Watson 1984), so that its use at this time was evidently more widespread than has hitherto been acknowledged. Two seventh-century Anglo-Saxon sword hilts of horn are now known (Cameron and Filmer-Sankey 1991), again suggesting more widespread practice, while the large metal-mounted drinking horns known from Sutton Hoo, Taplow and Broomfield are likely to have had many less impressive imitators. None of these items required much in the way of sophisticated treatment to produce them, and it is difficult to postulate the presence of a discreet professional stratum from the evidence available: entire horns merely need trimming and polishing, while handles can be cut from the solid tip of the horn without preparatory treatment. Two helmets with iron frameworks spanned by horn plates, one dated to the seventh century from Benty Grange in Derbyshire and the other from a rich Frankish grave at Cologne bespeak a more sophisticated treatment, for the horn plates in these instances would have required softening and bending into shape, techniques that lay at the heart of the medieval horner's craft and that hint at the emergence of a workforce already skilled to some degree in the treatment of horn (MacGregor 1985: 51–3).

Physical evidence for the state of the leather-worker's craft is even harder to find at the opening of our period, owing to the extreme rarity of surviving artefacts, although we can conjecture from the presence of numerous belt buckles and other such finds in pagan burials, including growing evidence for the covering of wooden shields with leather (Dickinson and Härke 1992: 51), that the technological base, for which there is plenty of evidence in the preceding Roman period, was already in place on the eve of the establishment (or rather re-establishment) of urban settlements, which were to have a major impact on the development of this craft. Its progress and that of the industries based on our other materials, can be followed through two broad phases of urban development: a proto-urban phase, culminating in a period of expansion under Viking and Norman influence, and a fully developed phase that was in place by the end of the medieval period.

At the beginning of our proto-urban phase, primary evidence for actual tanneries or horners' workshops is completely lacking but their existence can be inferred from other evidence. At Dorestad, for example, the presence of numerous horn-cores of sheep, goat and cattle, all sawn into sections to aid removal of the horn sheath, can be taken as clear signs of a functioning industry by the eighth century (Prummel 1978). Similar evidence comes from Ribe in Jutland, where the numbers of such horn-cores outweighed the other skeletal elements found on some sites to such

a degree that an industrial imperative could be clearly recognized (Ambrosiani 1981: 99–101). Menzlin on the southern Baltic coast has also produced sawn horn-cores indicating the presence of an early industry (Schoknecht 1977). The presence of tanneries can also be inferred from the evidence of other bones, due to the fact that until comparatively recent times it was the practice to leave the feet – including their associated bones – attached to the hide when the animal was flayed; in medieval Germany, for example, the custom of selling hides by weight, with the feet intact, is recorded. These were later removed by the tanner before he started work on the hide, with the result that tanneries produced quantities of very characteristic bone waste. (A recently published explanation for the regular attachment of the foot bones to hides suggests that these bones were, as in recent times, regularly boiled to produce neatsfoot oil, a particularly valued leather dressing; Serjeantson 1989: 141). Concentrations of foot bones conforming to this pattern have been noted, for example from medieval levels at King's Lynn. What is also possible is that the top of the skull with its horns attached may have been left attached to the skin, perhaps as a guarantee of the age, sex and species of the donor animal, so that horners and tanners may have been to some degree interdependent for supplies. It should be borne in mind too that the annual slaughter of livestock remained to some extent seasonal at this time, due to the difficulties in feeding animals throughout the winter months.

These trades are also similar in that the preparatory processes on which they rely are extremely lengthy: a year is commonly quoted as being the optimum period for soaking horn before it is worked, while ideal tanning times are given as a year to eighteen months. (An oath taken later by Leicester tanners not to sell leather that had been under a year and a day in the same liquor is of interest here, as are the conditions laid down in the Leather Act of 1563, which gave twelve months as the minimum period for soaking outer shoe leather and nine months for uppers; Cherry 1991: 297). Neither horning nor tanning, therefore, is suited to itinerant production, so that it was only with the advent of towns that conditions developed that allowed them to institute the kind of volume production they particularly needed in order to function efficiently.

This development seems to have been sufficiently far advanced by the end of our initial phase for fully settled tanneries to have appeared. The best known of these, discovered at High Ousegate in York in 1902–3, is generally dated to the Viking period or a little later (Benson 1902: 64–7; MacGregor 1978: 51–6). It comprises three large pits each some 7m × 3m

and set end to end. These features seem to have been enclosed within a building some 27.5m × 5m, with aisles to either side and fitted, perhaps, with racks spanning the pits. One pit had a thick layer of puddled clay at the bottom, one contained some 23cm of sand and the third some 13cm of lime. From what we know of later practice, the clay and sand in two of these pits can be equated conjecturally with the soaking process that formed a necessary prelude to treatment in order to plump up the dermal fibre network and render it receptive to the chemical agents. Commonly the initial washing of the hide was carried out in the open river, riverside sites consequently being particularly favoured by tanners. In later centuries in Chester, for example, several glovers and tanners are recorded as owning property 'by the waterside', an arrangement that, as well as providing access to the water, gave them more space than would have been available within the city walls (Woodward 1967). The calcareous deposit in the third pit at High Ousegate is thought to have derived from the liming process designed to loosen the hair from the hide, and extensive limestone debris found on adjacent sites has been similarly interpreted. (This part of the process may also be achieved, incidentally, by piling hides with hair sides together and sprinkling them with urine, a procedure that would be unrecoverable archaeologically). After the loosened hair had been scraped from the hide with a blunt, two-handled knife and the residual flesh and muscle had been removed from the inner surface, the hide was immersed in a strongly alkaline solution designed to open up its surface to the tanning agents. Favoured ingredients for these infusions included chicken manure, dog excrement, stale beer and urine: small wonder that tanners, like skinners, were not greatly sought after as neighbours. Many fragments of eggshell found in layers with evidence of leather-working at Pavement in York have been taken to represent the most durable element of the sweepings from henhouses used in such a solution (Buckland *et al*. 1974: 29), while the proximity of a tannery to a dovecote in Winchester has been regarded as perhaps significant in this context (for the Winchester leather industry, see Keene 1985: 285-92). The site at Pavement also produced quantities of elderberry seeds, capable of being used in preparing skins, while the rich fauna of carniverous beetles from the site no doubt fed on the fleshy waste.

Before tanning, the hide would have been divided up according to the different qualities of its constituent parts, each of which required some adjustment of the treatment to bring out its best characteristics. The actual tanning process would have required further pits, in which layers of vegetable tanning material (generally oak bark) and hides were alternated until the pit was full, before being covered with water. Further varieties

of beetle provide some of the earliest evidence associated with this part of the process, for some of the species identified are normally to be found under the bark of growing trees and are thought to have been introduced to the site along with the bark. Analysis of leather fragments from York have suggested that oak tannin formed the tanning agent (MacGregor 1982: 154, note 19) and indeed this remained the standard method of tanning for 90 per cent of the hides treated in England until the mid-nineteenth century. Salzman (1923: 247) records that the inventories of tanners operating in Colchester c.1300 all included quantities of oak bark among their possessions and mentions that the use of other agents was positively prohibited. (I have not dealt here with the craft practised by the tawyers, who operated separately from the tanners, concentrating on the skins of sheep, goats, deer and dogs, the last for gloves; after preparation as above these skins were placed in tubs and trampled in a paste of alum, egg yolk, oil and flour, before being stretched, dried and softened ready for manufacturing: see Waterer 1968.) Final treatments on the part of the tanner included deliming the skin to avoid a harsh surface appearance and 'bating', a process designed to counteract the plumped up state of the leather and render it soft and pliable. This called for further immersion in noxious solutions which, until as recently as the 1930s, were composed of dog, pigeon and hen dung but now rely on enzymes extracted from other sources.

The final part of the preparatory treatment fell to the currier, whose craft in later times was entirely separated from that of the tanner. The currier dampened and softened the leather in warm water, before scouring its surfaces and smoothing them with a stone or metal slicker. He shaved the leather to a standard thickness and impregnated it with dubbin (tallow and fish oil) before selling it on for manufacture. The point at which curriers emerged as a separate craft between the preparatory and the manufacturing trades is not yet clear: Keene (1985: 288–9) finds evidence that this separation occurred only in the fourteenth or fifteenth century in Winchester.

Leather artefacts are well represented at York, where changes in the river regime led to the build-up within a short space of time of extensive organic-rich layers (MacGregor 1982: 136–43; Tweddle 1986: 237–56). Much of the leather found has a tendency to delaminate owing to incomplete tanning, indicating that the technique was still in the process of refinement. Many offcuts from the edges of the hide incorporate holes whose distorted outlines suggest that they served in holding the hide under tension while it dried out. The most common artefacts are shoes and ankle boots of consistent appearance, showing a well established

tradition at work. There are also many worn soles that have been cut away from their uppers to be replaced with entire new soles, indicating the emergence of the cobbler as well as the shoemaker. A rare find from Viking levels in York was a wooden last, showing extensive signs of use (MacGregor 1982: 144–5, Fig. 74). (For shoes from medieval London see Grew and de Neergard 1988). Scabbards represent the most impressive products of the industry, and often had embossed decoration lavished on them (see, for example, Tweddle 1986: 237–42; Cowgill *et al*. 1987): these are already so distinctive in character that a specialized group of producers, independent of the shoemakers, may be postulated with some certainty. This embossing technique was to evolve to the level of a high art in succeeding centuries with the development of methods of hot-moulding wet leather and drying it out under heat so that it retained its new form. In producing goods of the type known generically as *cuir bouilli*, the moulded leather was dipped in boiling water for one or two minutes, melting the aggregates of fixed tannin so that they redistributed themselves in the fibre network and set permanently on cooling. Highly complex results could be achieved in this way, and the method was applied to items such as coffers and armour, as well as to more mundane products like blackjacks or jugs, and costrels or travelling bottles of various sizes.

Within the horn industry at this time, no workshops have been identified and actual artefacts remain scarce, owing to their tendency to disintegrate. Two horn combs now known from London and one from York, however, cast an interesting light on the state of the current technology (MacGregor 1985: 95, Fig. 52). All three of these have their teeth cut on a single sheet of horn – and the major advantage of this material is that composite construction is unnecessary – but they are fitted with riveted bone side-plates which, since they have no connecting function, must have been designed to prevent the comb from warping, a device that no self-respecting medieval horner would have countenanced. Incidentally, these form a rare instance of workers in horn combining bone with their products; otherwise, the two industries seem to have operated quite separately.

Artefacts of bone and antler continue to appear amongst the products of the earliest industries represented in towns, but their status in these early phases remains obscure. In England, Southampton has produced the most coherent evidence for an industry based on bone, during the earliest phases of settlement at Hamwic (Driver 1984; Riddler 1992: 150–51). Here rubbish pits filled with uniform offcuts of bone testify to well established routines centred on the exploitation of cattle limb bones

(particularly the metapodials) and to a lesser extent specific sheep bones, which were used in the manufacture of a particular type of low quality comb not so far found elsewhere. One particularly promising site at Chapel Road, although restricted in area, produced over 1,700 offcuts, largely of cattle bone with some lesser use of horse metapodials, providing evidence of what may prove to be a peculiarly characteristic Middle Saxon reliance upon bone rather than antler.

Among the early towns on the Continent producing analogous evidence, Münster has provided ample signs of a well established industry producing composite combs from horse bone in the eighth century: complete and partly-finished combs were found on the site, along with the sawn ends of some 300 horse bones (Winkelmann 1977). At Dorestad sawn waste bone similar in character to that from Münster and Southampton implies the presence of similar activities, even though the end-products have not been recovered in large numbers (Clason 1980). What is most significant about these scattered finds is their uniformity of character, for in these well-established practices we may now be justified in discerning professional activity.

During the Viking and Norman phases much more detail can be added to the status of these industries, which enter this phase in fully developed form and then start to undergo the changes that led to the form in which we encounter them in the high Middle Ages. By now the sheer volume of evidence allows more precision to be brought to bear on the question of supply of raw materials. A striking feature is that antler continues to outweigh bone by a huge amount in terms of the materials consumed by the industry. Examination of the offcuts and waste material from a number of sites produces a remarkably consistent picture, in which a further point of interest emerges: in every case where quantities of the diagnostic bases of antlers have been found, shed antlers predominate significantly over those from slaughtered animals. The immediate impliction is that while beasts slain for sport or food contributed a certain amount of raw material, the urban industry depended for the bulk of its needs on antlers collected in the countryside during the annual shedding season. The paucity of skeletal bones of red deer in the food refuse of towns in this period confirms this picture, which is repeated at York, Lincoln and Dublin, where the largest quantities of material have been examined in this country, and at other north European settlements such as Ribe, Århus and Hedeby on the Jutland peninsula, at Dorestad in Holland, and at Menzlin and Wolin on the southern Baltic coast (see MacGregor 1989: 113–15; MacGregor 1991: 366–76). Statistical methods have been used to show that some of these

antlers were brought over considerable distances, a practice that can be seen more readily in settlements lying near the limits of species distributions: Birka on Lake Mälar in Sweden, for example, lies beyond the northern limit of the red deer, so that the presence of red deer antlers among the industrial waste recovered there carries clear implications, as does the presence of elk antler at Ribe and Dorestad, which lie below the southern limit of the elk, and reindeer antler found at Lund and Lödöse in southern Sweden, as well as at Hedeby, which are similarly outside the reindeer's habitat (MacGregor 1985: 32–8).

It would be over simplistic to see the antler-workers as being entirely passive or static in this centralising process. Even at Hedeby, where by far the largest quantity of evidence has been found, the excavators were not able to envisage the volume of production represented by over a quarter of a million waste and worked fragments as being sufficient to maintain a community of full-time settled workers (Ulbricht 1978: 117–19). As an alternative to the part-time manufacturing suggested there, and reiterated at the Medieval Europe conference in 1992, where speakers from Trondheim and Sigtuna respectively suggested that the comb manufacturers in their respective towns were also coppersmiths and blacksmiths (Nordeide 1992; Ros 1992), it might be preferable to envisage the comb-makers at this time as still being engaged for part of the working year in itinerant production, which would carry them to markets outside the towns and into direct contact with the rural suppliers of their raw material. Such a *modus operandi* has found favour with researchers working independently with evidence from Lund and from Ribe, where a phase in which manufacturers were settled in the urban context for only part of the year has been postulated for the earliest levels of both towns (Christophersen 1980; Ambrosiani 1981: 157–62).

In the course of the early medieval period, significant changes overtook the industries depending on bone and antler, although it was a process that happened at different rates in different places in northern Europe. It can be demonstrated most strikingly by comparing the evidence from the town of Schleswig, a new foundation that effectively replaced nearby Hedeby after the Viking settlement was sacked in 1066. Here, in contrast to the preponderance of antler utilized at Hedeby, an undoubted reliance by manufacturers on animal bone can be recognized (Ulbricht 1984). Clearly the same mechanical characteristics continued to mark antler as a superior material and the deer themselves were still to be found in large numbers, so presumably some new factor began to exert an influence at this time. To some degree the extension of controls over the forests may have had an influence in bringing about this change

(including management of woodlands for coppicing), but more probably it was the centralising effect of the growing towns, in which bone and horn became available in ever increasing quantities. Conversely, increasing sedentariness weakened the close links with the countryside that had marked the itinerant phase of comb production and hence limited the opportunities for direct interchange of antlers. Evidence of such sedentarism within the industry is still hard to find archaeologically, but at Wolin in northern Poland one workshop has been identified in which evidence of production by several successive generations of comb manufacturers has been postulated (Cnotliwy 1958). From a technological point of view, comb manufacturers seem for a time to have made use of the limb bones of cattle and horses in producing their traditional composite combs, but before long these forms went quite out of use to be replaced by one-piece combs, of necessity much smaller in size, being limited by the width of the bones available. The trapezoid outline of these early one-piece combs seems to me to betray the influence of another of our materials: tapering, cylindrical sections of cattle horn opened up to form a flat plate adopt exactly this shape, and again the indirect evidence for the early success of the horn industry seems more persuasive than the small quantity of artefacts recovered might suggest.

This change in working practice can also be detected in the British Isles, but with less chronological precision. In Scandinavia, it seems, traditional antler composite combs survived well into the thirteenth or even, it is claimed, the fourteenth century, but in Britain the changeover seems to have been completed in the course of the twelfth century (MacGregor 1985: 81). Further developments were under way contemporaneously, which led to the production of one-piece combs similar in appearance to those of bone but made in a range of other materials – wood (mostly boxwood), cattle horn, and even ivory. In this changeover we may see the end of one system of production in which producers who were dedicated exclusively to the utilisation of antler were replaced by manufacturers who concentrated on the production of a particular product, the comb, and who worked with equal facility in a range of materials. When the comb-makers emerge into the historical record, this process had already been completed, for by the time they are recognised within the guild structure in London they are certainly not bound to any one material.

The other major products of the antler workers, namely knife handles, emerge similarly in the early history of the Cutlers' Company as being entirely under the control of the cutlers and no longer in the hands of freelance antler workers (Welch 1916–23: I, 19–21). Interestingly, one

of the few claims for the discovery in England of the working of bone and horn within a single workshop along with iron and bronze, comes from what is interpreted as a cutler's workshop in Worcester (Carver 1980: 174). Other indications for the continuing utilisation of bone appear in the form of waste from button manufacture, in which discs of bone were used as formers for cloth-covered buttons. Again the producers of these discs cannot be shown to have made any other products apart, perhaps, from bone beads for necklaces and rosaries: significantly, a seventeenth-century German source mentions that at that time rosary-makers continued to produce bone blanks for button-makers, who would cover them with silk or threadwork (Weigel 1698: 452–9). Evidence for rosary-making in the fifteenth or sixteenth century at Saint-Denis provides an example of one context in which extraordinary concentrations of persons – in this case pilgrims to the tomb of Saint Louis – could create (albeit discontinuously) markets of sufficient size to support manufacturers (Meyer 1979: 2.2.1); the producers of lead alloy pilgrim badges at Canterbury represent an analogous case.

Primary archaeological evidence for horn-working emerged in the 1950s during excavations at Hornpot Lane in York, where a clay- and timber-lined pit containing some 200 horn cores, mostly of cattle and goat, was uncovered along with a series of hearths (Wenham 1964: 23–54; Ryder 1970: 418–28). This is the only instance where hearths associated with horn-working have been found, although concentrations of horn cores are commonly found in pits and dumps in medieval contexts. Cattle account for the vast majority of these, but at Skeldergate in York the presence of numerous goat horn cores in the absence of other goat bones shows that these too were being imported to the site for processing (O'Connor 1984: 20, 28–9). Not all dumps of horns need represent the sites of horners' workshops, however, and indeed a series of thirteenth-century pits at 's-Hertogenbosch in the Netherlands, associated with over 130 horn cores of cattle and goat, have been identified specifically as tanning pits (Prummel 1978). Needless to say, the horns themselves would no doubt have been destined for the horner in the normal course of events. Untreated horns may have formed the basis of a regular trade over considerable distances in the medieval period: an Act of Parliament of 1465 prohibited the export of rough horns from within a 24-mile radius of London until the needs of the London Horners' Company had been satisfied (MacGregor 1991: 372), and since, by the end of the fourteenth century, horns were already being imported both in their raw state and ready prepared for use as lantern panes, demand seems to have far outstripped supply.

As well as the combs already mentioned, beakers formed a major staple of the horner's craft. These were made from cylindrical sections of horn in which an internal groove was cut around the bottom and the horn heated to allow insertion of a discoid base, which were a tight fit when the horn cooled. Inkwells, spoons and lantern panes formed other major products. Some houses indeed had horn window panes, a convention of which we know almost nothing but for a reference of 1580 to the fact that the rise in the use of glass had ruined this aspect of the trade. Later on, horn books, spectacle frames and snuff boxes were to be added to the repertoire of the horner. Inkhorns, 'blowyng hornes', 'drynkyng-hornes' and 'goblets de cornibus' were all being imported from the Continent in the fourteenth century (MacGregor 1989: appendix).

Archaeological evidence for the leather industry remains throughout the medieval period more plentiful in the form of finished products than preparatory installations, and historical references reveal evidence of a kind that lies beyond the capacity of archaeology to recover. The processes by which hides reached the tannery from the countryside are a case in point: we learn from documentary sources of middlemen named fellmongers, who played an important part in acquiring skins from butchers and farmers and in selling them on to the tanners. Pedlars who bought the pelts of fur-bearing animals from huntsmen, villagers and foresters and sold them to furriers are also recorded from these sources, providing an historical analogue for the method of antler gathering postulated above.

Amongst the physical evidence for tanning from this period must be numbered pairs of tanning pits, one of each pair containing lime, found in a late thirteenth-century context at Exe Bridge and at High Street, Exeter (Allen 1984). Further discoveries of tanning pits have been made at 's-Hertogenbosch in the Netherlands, their function being established only from the animal bones, of which almost a third were horn cores (Prummel 1978), and at Basel, where 166 horn cores as well as foot bones of goat, in association with leather fragments and deposits of vegetable material interpreted as bark used in tanning, provided persuasive evidence for the presence of an early medieval tannery (Schmid 1969; Schmid 1973). Not until the sixteenth century does archaeological evidence emerge for a large scale workshop, with the discovery at Northampton of an extensive complex of pits, tentatively interpreted as representing the remains of as many as four neighbouring tanneries (Shaw 1984). The complex, sited on the south-western edge of the town, adjacent to a channel of the River Nene, is in the area of Tanner Street: at least forty-six pits were discovered here in 1983, in addition to a

further nine uncovered earlier on an adjacent site. They contained deposits of lime and wood ash relating to the processes already described, and in addition the back-fill of several of these pits produced large quantities of horn cores.

Apart from the evidence from Basel, pits containing evidence for the actual tanning process in the form of deposits of bark remain elusive at this time. We know, however, that the bark was harvested by stripping growing trees in a routine akin to coppicing, generally on a cycle of about thirty years (Clarkson 1974; Cherry 1991: 300). It then had to be ground up, perhaps in a mortar or stone-lined pit, although no such pits are known. A water-driven bark mill is referred to in a document of Notre Dame of Paris dated 1138, and it has been suggested that monasteries may have had an important influence in spreading water-powered bark mills. By 1297 a tanning mill was recorded at Newbury and another was functioning at Okehampton around the same time, but no such mill has ever been excavated.

To what degree tanning was practised in the countryside as well as the town is not clear, but in 1184 the Assize of the Forest ordered tanners and tawyers to dwell within a borough, implying that not all had hitherto done so. A number of monastic tanneries are also recorded from the thirteenth and fourteenth centuries. It seems likely that tanning was carried on in many towns in the Middle Ages – at least those with easy access to the necessary supplies of bark – and was still widespread in the nineteenth century, when 131 towns and villages in Cornwall are recorded as possessing tanners (Cherry 1991: 301). Although tanning was not an industry practised exclusively in the urban context, therefore, it seems likely that the products of these smaller rural tanneries also gravitated to the larger towns, for it may be doubted that a viable market could be made for all their production amongst the country population.

The trades concerned with the production of leather goods continued to be clearly separated from those involved in tanning. Early guild regulations make it clear that butchers were not permitted to be tanners, that tanners could not be curriers, and that curriers could not also be shoemakers. These divisions occasionally broke down in the towns, as for example in fourteenth-century Chester where the tanners obtained a charter forbidding cordwainers from encroaching on their trade, only to have the decision reversed as contrary to the interests of the city (Woodward 1967). In the rural context such divisions were no doubt much rarer.

Very often it is the skinners that emerge as the most successful within these related trades. Figures from the 1381 tax returns in Oxford, for

example, show skinners and tanners as the most affluent, with cordwainers and cobblers less so (Cherry 1991: 309). At any one time they had considerable sums tied up in hides under preparation, which they invariably sold wholesale to the leather-working trades. They are also found occasionally to have quantities of horns included in inventories of their assets, similarly destined for wholesale trade. At Winchester too, Derek Keene (1985: 285) has commented that in the earlier part of the fourteenth century skinners were the wealthiest and most influential occupational group in the city, owning property more frequently than the tanners.

Whereas there were some environmental limitations on the practising tanner, chiefly the availability of bark, the establishment of manufacturing crafts depended only on suitable concentrations of population. While long-distance trade in prepared hides is a theoretical possibility, research in one such manufacturing centre – Chester – has shown that in the Tudor and Stuart periods the city's leather-workers remained dependent to a large degree on the surrounding countryside both for their primary market and for their raw materials (Woodward 1967: 75–82). Leather-workers were numerically the most important trade in York in the thirteenth century, representing 30 per cent of freemen, although by the fifteenth century the figure was less than half that.

By now the leather-workers were wholly integrated into all the major population centres, and operated as full partners in the urban economies that had provided the initial means of graduating from country craft to high-volume urban industry.

References

Allen, J. P. (1984) *Medieval and Post-Medieval Finds from Exeter 1971–1980*, Exeter Archaeological Reports 3, Exeter.
Ambrosiani, K. (1981) *Viking Age Combs, Comb Making and Comb Makers in the light of Finds from Birka and Ribe*, Stockholm Studies in Archaeology 2.
Benson, G. (1902) "Notes on excavations at 25, 26 and 27 High Ousegate, York', *Annual Report of the Council of the Yorkshire Philosophical Society*, 64–7.
Buckland, P. C., Greig, J. R. A. and Kenward, H. K. (1974) 'York: an early medieval site', *Antiquity* **48**, 25–33.
Cameron, E. and Filmer-Sankey, W. (1991) 'An Anglo-Saxon sword hilt of horn', *Anglo-Saxon Studies in Archaeology and History* **6**, 103–5.
Carver, M. O. H. (1980) *Medieval Worcester: an Archaeological Framework*, Transactions of the Worcestershire Archaeological Society, 3rd series **7**, Worcester.
Cherry, J. (1991) 'Leather', in *English Medieval Industries*, J. Blair and N. Ramsay (eds), London, 295–318.

Christophersen, A. (1980) 'Raw material, resources and production capacity in early medieval comb manufacture in Lund', *Meddelanden från Lunds Universitets Historiska Museum*, new series 3, 155–65.

Clarkson, L. A. (1966) 'The leather crafts in Tudor and Stuart England', *Agricultural History Review* **14**, 25–46.

Clarkson, L. A. (1974) 'The English bark trade, 1660–1830', *Agricultural History Review* **22**, 136–52.

Clason, A. (1980) 'Worked bone and antler objects from Dorestad, Hoogstradt 1', *Excavations at Dorestad* 1 *The Harbour: Hoogstradt 1,* Nederlandse Oudheden 9, Amersfoort, 238–47.

Cnotliwy, E. (1958) 'Wczesnośredniowieczne przedmioty z rogu i kości z Wolina, ze stanowiska 4', *Materiały Zachodnio-Pomorskie* **4**, 155–240.

Cowgill, J., de Neergard, M. and Griffiths, N. (1987) *Knives and Scabbards*, Medieval Finds from Excavations in London 1, London.

Driver, J. C. (1984) 'Zooarchaeological analysis of raw-material selection by a Saxon artisan', *Journal of Field Archaeology* **2**, 397–403.

Grew, F. and de Neergard, M. (1988) *Shoes and Pattens*, Medieval Finds from Excavations in London 2, London.

Keene, D. (1985) *Survey of Medieval Winchester*, I, part I, Winchester Studies 2, Oxford.

MacGregor, A. (1978) 'Industry and commerce in Anglo-Scandinavian York', in *Viking Age York and the North*, R. A. Hall (ed.), CBA Research Report 27, 37–57.

MacGregor, A. (1982) 'Anglo-Scandinavian finds from Lloyds Bank, Pavement, and other sites', in *The Archaeology of York* 17, P. V. Addyman (ed.), London, 67–174.

MacGregor, A. (1985) *Bone, Antler, Ivory and Horn. The Technology of Skeletal Materials since the Roman Period*, London.

MacGregor, A. (1989) 'Bone, antler and horn industries in the urban context', in *Diet and Craft in Towns*, D. Serjeantson and T. Waldron (eds), BAR British Series 199, 107–28.

MacGregor, A. (1991) 'Antler, bone and horn', in *English Medieval Industries*, J. Blair and N. Ramsay (eds), London, 355–78.

MacGregor, A. and Currey, J. (1983) 'Mechanical properties as conditioning factors in the bone and antler industry of the 3rd to the 13th century AD', *Journal of Archaeological Science* **10**, 71–7.

Meyer, O. (1979) *Archéologie Urbaine à Saint-Denis*, Saint-Denis.

Nordeide, S. W. (1992) 'Specialist or Jack-of-all-Trades in medieval Trondheim', *Medieval Europe 1992* **VII**, 143–8.

O'Connor, T. P. (1984) 'Selected groups of bones from Skeldergate and Walmgate', in *The Archaeology of York* 15, P. V. Addyman (ed.), London, 1–60.

Prummel, W. (1978) 'Animal bones from tannery pits at 's-Hertogenbosch', *Berichten van de Rijksdienst voor het Oudheidkundig Bodemonderzoek* **28**, 399–422.

Riddler, I. (1992) 'Boneworking and the pre-Viking trading centres', *Medieval Europe 1992* VII, York, 149–56.

Ros, J. (1992) 'Antler and bone handicraft in late Viking Age and early medieval Sigtuna', *Medieval Europe 1992* **VII**, 157–62.

Ryder, M. L. (1970) 'The animal remains from Petergate, York, 1957–58', *Yorkshire Archaeological Journal* **42**, 418–28.

Salzman, L. F. (1923) *English Industries in the Middle Ages*, 2nd edn, Oxford.

Schmid, E. (1969) 'Knochenfunde als archäologische Quellen', in *Archäologie und Biologie*, Forschungsberichte 15, 100–11.

Schmid, E. (1973) 'Ziegenhörner als Gerberei-Abfall', *Schweizer Volkskunde* **63**, 65-6.

Schoknecht, U. (1977) *Menzlin. Ein frühgeschichtlicher Handelsplatz an der Peene*, Berlin.

Serjeantson, D. (1989) 'Animal remains and the tanning trade', in *Diet and Crafts in Towns*, D. Serjeantson and T. Waldron (eds), BAR British Series 199, 129-46.

Shaw, M. (1984) 'Northampton: excavating a 16th-century tannery', *Current Archaeology* **91**, 241-4.

Tweddle, D. (1986) 'Finds from Parliament Street and other sites in the City centre', in *The Archaeology of York* 17, P.V. Addyman (ed.), London, 175-282.

Ulbricht, I. (1978) *Die Geweihverarbeitung in Haithabu*, Die Ausgrabungen in Haithabu 7, Neumünster.

Ulbricht, I. (1984) *Die Verarbeitung von Knochen, Geweih und Horn im mittelalterlichen Schleswig*, Ausgrabungen in Schleswig, Berichte und Studien 3, Neumünster.

Waterer, J. W. (1968) *Leather Craftsmanship*, New York.

Watson, J. (1984) 'Organic material associated with metal objects', in *The Anglo-Saxon Cemetery at Spong Hill, North Elmham Part III: Catalogue of Inhumations*, East Anglian Archaeology Report 21, C. Hills, K. Penn and R. Ricketts, Gressenhall, 157.

Weigel, C. (1698) *Abbildung der ... Haupt-Stände von denen Regenten ... bis auf alle Künstler und Handwerker*, Regensburg.

Welch, C. (1916-23) *History of the Cutlers' Company of London*, London.

Wenham, L. P. (1964) 'Hornpot Lane and the horners of York', *Annual Report of the Yorkshire Philosophical Society*, 25-36.

Winkelmann, W. (1977) 'Archäologische Zeugnisse zum frühmittelalterlichen Handwerk in Westfalen', *Frühmittelalterliche Studien* **11**, 92-126.

Woodward, D. M. (1967) 'The Chester leather industry, 1558-1625', *Transactions of the Historical Society of Lancashire and Cheshire* **119**, 65-111.

♦3♦

The Search for Anglo-Saxon Skin Garments and the Documentary Evidence

Gale R. Owen-Crocker

The Anglo-Saxon settlers were of Germanic stock, coming largely from present-day southern Scandinavia and northern Germany; and if we look at early records of what Germanic people wore, it is clear that skins were a crucial part of their costume, indeed, in some cases, their only costume. Julius Caesar, writing in the first century BC, speaks of the hardiness of the German people and claims that they were accustomed to go about wearing only short garments of fur or skin, which left most of the body bare, and to Roman eyes quite indecently exposed.[1] He calls these coverings *pelles*, adding at one point the alternative *parvis renonum tegmentis* (Edwards 1917: vi, 21, 346), which might be translated boldly as 'small cloaks of reindeer hide', or, more cautiously, as 'little coverings of fur'.[2] It has generally been supposed that these garments were small cloaks: leather capes have been found in Danish peat bogs (Hald 1980: 313–22, Figs 359–78, 380) and the sculpture of German prisoners on a Roman sculpture from Mainz (Fig. 1) has been supposed to show what Caesar describes (Hald 1980: 320). If the capes are skin, rather than cloth, which is not indisputable, the fur would seem to have been worn inside, as in the Iron Age Danish finds. However, if one takes into account Isidor of Seville's definition of *reno* as a garment which covers the shoulders and chest and reaches to the navel (Lindsay 1911: ii, 19, 23, 4), a poncho-shaped cloak rather than a cape-like garment may be closer to what Caesar meant. A depiction of a poncho-like garment is known from the Adamklissi Monument, Romania (Fig. 2). Ponchos of animal skin were certainly worn by primitive northern peoples, including Russians and Eskimos, and, in exploiting the correspondences between animal and human anatomy, required little adaptation of shape (Hald

1980: 347–54). There seems little to confirm that the *reno* could only be made of reindeer hide, which is inconveniently narrow for human wear (Hald 1980: 384 n.113). Indeed, Du Cange (1883–87) includes two citations suggesting that it was of lambskin (*agnitis*). In any case, the

1. Short capes, perhaps of skin. Sculpture from Mainz.

2. Poncho, probably of skin. Adanklissi monument.

28

natural distribution of the reindeer (of which Julius Caesar could have had no direct knowledge) does not reach as far south as the southern provinces of Sweden.

Another major Roman source of information on the early Germans, Tacitus, speaks of the importance of skins in their dress,[3] although this time their use seems to be in addition to cloaks and other garments of cloth. Tacitus declares that the tribes living in his day near the river, that is the Rhineland Germans, wear skins fairly casually, whereas the more distant tribes, who cannot depend on traders for clothing, tailor them with more care. Presumably he means distant from the river, and Rome, but not necessarily from the sea, since the fur of sea creatures is mentioned specifically. Tacitus describes deliberate selection of skins and seems to be saying that the people mixed the skins of land animals with the skins of 'spotted' or 'marked' (*maculis*) sea creatures. He refers to the outer ocean here, so these creatures are not to be found merely around the river mouth. There are several species of seal that would fit the description.[4] Did they mix them in garments with marten or squirrel?

Since skin garments were such a well established part of Germanic costume, we might expect them to continue to feature in the dress of the Anglo-Saxons who settled in parts of England from about the fifth century AD; but once we have traced the settlement of the Germanic people in England, leather and fur become elusive. Until they were converted to Christianity the Anglo-Saxons did not write, their art was rarely naturalistic with human beings infrequently depicted, so they have left us virtually no written or graphic evidence of what they were wearing for the first century and a half after the settlement.[5] When they do eventually represent the human form naturalistically in art, it is not clad in skin garments. From the late Anglo-Saxon period we have a considerable number of manuscript illuminations, both the formal, fully painted miniature and the line drawing; but representations of leather and fur garments are lacking.

It is apparent that there was no graphic problem in depicting fur. Anglo-Saxon artists could do it if they wanted to. An allegorical figure representing Superbia (Pride), in a cycle of illustrations to Prudentius's poem *Psychomachia*, has fur under her horse's saddle (Fig. 3) illustrating the lionskin specified in the text.[6] A bag round the neck of a beggar in an eleventh-century Canterbury copy of the Utrecht Psalter seems to be fur, with tails attached (Fig. 4).[7] In a miniature from the early tenth-century Benedictional of St Ethelwold showing the baptism of Christ, John the Baptist is traditionally dressed in an *exomis* of fur (Fig. 5). This is however, a derivative illumination; despite the Christian subject matter

3. Superbia, *with a skin saddlecloth. From London, British Library Manuscript Additional 24199, fo.12 (by permission of the British Library).*

4. *Beggar with a skin bag. From London, British Library Manuscript Harley 603, fo.66v.*

5. *John the Baptist, in a fur tunic. From London, British Library Manuscript Additional 49598, fo.25.*

there is a pagan river god in the bottom corner, and the fur garment is probably just such another inherited detail, not repeated in extant Anglo-Saxon art. Over a hundred years later, probably in the 1080s, the embroiderers of the Bayeux Tapestry also had no difficulty in depicting fur, this time as one of the rich wrappings for the corpse of King Edward the Confessor (Fig. 6). Yet I find it surprising that the aging king, pictured immediately before the death scene with a walking stick replacing his sceptre, and his straggling beard embroidered a sickly green (Wilson 1985: pl.28), did not comfort his old bones with a bit of fur. Likewise, the artist of an illustrated Old English Hexateuch, depicting the aged Abraham, does not have recourse to furs (Dodwell and Clemoes 1974: fo.66v). The argument that the climate of the Bible lands would not need warm clothing is inappropriate – the Hexateuch artist showed the buildings, tools and clothing of western Europe and seems to have been more realistic than most. The answer to the absence of fur clothing may be, however, that even a relatively innovative artist of the late Anglo-Saxon period was heavily dependent on models, which came, often through Carolingian intermediaries, from the Mediterranean, where perhaps there was no tradition of fur garments. Even huddling over a November fire in an illustrated Anglo-Saxon calendar, the figures wear fairly skimpy cloth garments.[8] The calendars themselves, and the agricultural occupations chosen to illustrate each month, reflect Roman tradition.

6. *Edward the Confessor's body is shrouded in fur. The Bayeux Tapestry (with special permission of the City of Bayeux).*

The Bayeux Tapestry possibly shows the use of leather for protective clothing.[9] I would like to consider three different possibilities. The first case concerns a group of Norman archers at the Battle of Hastings (Fig. 7). Each individual appears to be dressed slightly differently, one has a cap (very unusual in the art of this period) and another seems to have patches on his clothes, which might be interpreted as protective leather guards. I would not push this too far since I have shown (Owen-Crocker 1994) that the variation in these costumes probably stems from the areas of colour selected by the embroiderer, rather than the defining lines of the cartoon. If we consider the distinctive strap for the quiver, worn with culottes, by the upper figure and compare the stem stitched lines on the dress of this other figure, it will be seen that the strap may have been created by the embroiderer misunderstanding the cartoon. The same hand has created a unique Peter Pan collar on this figure, by taking the coloured silk for the garment further up the neck than was intended; so little confidence can be placed in the possible leather patches on the archer.

Another possibility is Bishop Odo's fighting suit (Fig. 8). Odo, Bishop of Bayeux, William the Conqueror's half brother, is currently believed to have commissioned the Tapestry. As a cleric he was forbid-

7. *Norman archers. The Bayeux Tapestry (with special permission of the City of Bayeux).*

8. Bishop Odo in battle dress. The Bayeux Tapestry (with special permission of the City of Bayeux).

den to carry arms, but he appears, heroically, on the battlefield to rally the troops. The caption reads: *Hic Odo eps. baculu tenens confortat pueros:* 'Here Bishop Odo, carrying a stick, encourages the lads'. Odo's costume is the same shape as the other men's, but whereas they have mail, indicated by embroidered circles, Odo wears a suit of interlocking triangles, embroidered in contrasting colours. A similar suit, of triangles and rhomboids, is worn in an earlier scene by one of the men riding to Mont St Michel (Fig. 9, right). It has been assumed that the distinctively dressed figure is Duke William, who is named in the caption (Nevinson 1947: 72; Wilson 1985: 179), but I would argue from the fact that he carries a club and from the spatial organization of the scene that it is Odo.[10] It is possible that, just as the bishop carries only a wooden, not a

9. The ride to Mont St Michel. The Bayeux Tapestry (with special permission of the City of Bayeux).

metal weapon, so he wears a leather rather than a metal garment. However, in the battle scene he has mail at the neck and wrists, so, unless there is an error here by designer or embroiderer, he was presumably not forbidden to wear it. He could, perhaps, have worn a protective suit of leather over his mail, but this would seem unnecessary. My own opinion is that we do not have a leather garment represented here but that the change of pattern and the contrasting colour are techniques designed to distinguish Odo without pre-empting his brother the Duke. Colour contrast had earlier been used to distinguish Earl Harold from among a group of men, in that case by embroidering the skirt of his tunic in stripes (Wilson 1985: pl.7). In that scene, Guy of Ponthieu, wearing culottes, confronts Harold from horseback, and shortly after is to face the enormous thug-like figures of Duke William's men. He does so in a tunic with an elaborate scalloped pattern worked in contrasting colours (Fig. 10). I would suggest that again the embroiderers are indicating a major figure and relieving their boredom at the same time. With his hand on his hip and his patterned outfit he looks a bit effete, but if we consider

10. Guy of Ponthieu confronting William's men. The Bayeux Tapestry (with special permission of the City of Bayeux).

that he is holding a very large axe, and that his costume might have been of leather scales, his posture could be interpreted as one of defiance.

Having reviewed the doubts surrounding these depictions, we must look to textual evidence for any positive indication that leather or fur garments were being worn in Anglo-Saxon times. As far as I know, the only description of Anglo-Saxon clothing by an Anglo-Saxon is in a tract on virginity by Aldhelm, who composed in a tortuous form of Latin in the late-seventh to early-eighth centuries. Aldhelm condemns the frivolous ways of some people vowed to the religious life, and lists the extravagances of their dress. Unfortunately it is not always clear when Aldhelm refers to both sexes and when only to women, or precisely what his words mean (Owen-Crocker 1986: 87–90). Some item of dress was evidently circled with red-dyed skins (or fur), *galliculae rubricatis pellibus ambiuuntur;* this item, *galliculae*, is usually taken to be a variant of *calligulae*, boots.[11] In an attempt to find references to clothing in the native language of the Anglo-Saxons, Old English, I originally (Owen 1976; Owen-Crocker 1986) looked through every item in Bosworth and Toller's *Old English Dictionary*, and until recently there has been no alternative to this method if the evidence is to be covered systematically. This is a laborious business, since Bosworth's first volume, published in 1822, has never been rewritten. Hence everything has to be looked up three times: once in the first volume; once in the second, where all the things that were omitted from the first were printed; and finally in Campbell's Supplement to the second volume, which corrects and brings Bosworth and Toller up to date. The dictionary gives all known citations of words, unless they are very common, but the abbreviations for the citations are cryptic and many refer to what are now old and obscure editions of texts. There is now a new dictionary in progress, the 'Toronto *Dictionary*', which is being published letter by letter on microfiche (Amos *et al*. 1986). The dictionary itself, which is very helpful and accessible, has only so far reached D, but the contributory research has resulted in new, reliable editions of texts, a microfiche concordance to Old English,[12] and its computerised version, on the program Word-Cruncher.[13] One must still be a competent Old English scholar to use these tools, because they do not translate words into modern English, and the concordance does not cross-reference so one must know one's word and be able to conceive of alternative spellings in order to look it up.[14] When I checked my fur words on WordCruncher, it did not offer citations I did not know about, but I was unable to tell if there was a word for a fur or leather garment that I had not met before, because it simply lists all known Old English words alphabetically. Help is at hand,

however, in the shape of the Old English *Thesaurus* (Roberts *et al*. 1995). Professor Jane Roberts informs me that it includes sections on dressed hide, undressed hide, words for tanners and shoemakers, and of course, garments.

Even when one has found the Old English words and looked up the citations indicated by dictionary or concordance, a frustrating fact emerges; in Old English poetry and the other texts that we might reasonably call literature (such as prose homilies) clothing is not described and rarely mentioned, unless it is battle dress, mail or helmet. It is in the *non-literary* texts that one finds the Old English garment words. Even there, references to fur or leather are rare. There is the will of an Anglo-Saxon woman named Wynflæd, who, unusually, bequeathed several garments including *hyre twilibrocenan cyrtel*, which Dorothy Whitelock (1930: 15) tentatively translated as 'her double badger skin gown'. I have enquired about the feasibility of badger skin for garments and was told that the fur would be suitable, or that a soft leather might be made of the skin. I have argued elsewhere (Owen 1979) that *twilibrocen* is probably a technical term relating to weaving, and that *brocen* refers to a 'broken', or reversing, woven pattern, rather than to *broc*, 'a badger', but the possibility of a skin garment remains. In support, there is a reference in an Old English text to Scandinavian people having bear or otter skin cyrtles.[15] More informative about the fact that fur garments were treasured, but not in the details of what they looked like, is an entry in the D version of the Anglo-Saxon Chronicle, for 1075 (Plummer and Earle 1892–3: i, 209).[16] It records magnificent gifts given to Prince Edgar of England by King Malcolm of Scotland and Margaret, his wife. Margaret was Edgar's sister. They were the grandchildren of Edmund Ironside, great grandchildren of Ethelred the Unready, and, many would have thought, the rightful heirs to the English throne. The chronicler was at pains to show the richness of the gifts given by Malcolm and Margaret, demonstrating their generosity and indicating the esteem in which they held the prince. The prince and his men were given 'great gifts', *myccla geofa*, including *on scynnan mid pælle betogen and on merðerne pyleceon, and graschynnene, and hearma scynnene, and on pællon* ...as well as objects of precious metal. *Pælle* are high quality textiles. The first item, *on scynnan mid pælle betogen* seems to mean skins covered with textile. I think these were probably garments, but whether garments of expensive cloth lined with fur, or fur garments lined with fine cloth I am not sure. Anne Savage (1982: 205) translates this as 'skins faced with purple cloth'. The second item is *on merðerne pyleceon*, which is clearer. *Merðerne* means 'marten skin', and we can be confident that marten skins were being traded and

worn in the British Isles: Domesday Book mentions them being imported into Chester (Beamont 1863: 4),[17] and a Welsh lullaby, considered to be ninth-century, mentions the baby's father wearing a marten skin coat (Jackson 1969: 151). *Pylece* is definitely a 'fur' or 'leather' word but the exact nature of the garment it represents is unclear. It is found among a group of clothing terms glossing Latin *pellicia* (Wright 1884: 328, l.18) from which it derives, and as well as the Chronicle's association with marten skin it occurs in a reference to God making Adam and Eve *pylcan* of *deadum fellum* ('of dead skins') (Bouterwek 1858: 20, ll.28–9). Bosworth and Toller (1972) suggest *pylece* means a fur robe, on the strength of the Adam and Eve citation and an Icelandic cognate meaning fur coat, but I have my doubts. We all know which part of their bodies Adam and Eve were anxious to cover, and it may be relevant that 'pilch' has survived in dialect and popular usage as a garment, or protection, for the pelvic area.[18] I would not go so far as to claim that King Malcolm was bestowing marten skin loin-cloths, but I believe we cannot assert they were cloaks either. The chronicler goes on to mention [*pyleceon* of] *graschynnene* and *hearma scynnene*,[19] which have been translated as 'miniver' and 'ermine-skin', respectively (Garmonsway 1954: 209; Savage 1982: 205). 'Miniver' (a name in common use in later medieval times for the white belly skin of the red squirrel) is perhaps too precise a term for the purist. If the *gra-* in *graschynnene* is related to Old English *græg*, 'grey', a more likely identification would be the grey back of the squirrel's winter skin, called 'greywerk' or 'gris' in the later Middle Ages (Veale 1966: 219, 220, 228–9). A compound *hearmascynne*, although unique in Old English, may well signify the skin of the ermine, a weasel brown in summer, white in winter.[20] We have here lavish gifts, including various furs, which seem to have impressed an English chronicler. The fact that they were given by the King of Scotland may be significant; perhaps fur garments were characteristic of the more northern kingdom. It is also possible that the taste of Margaret and Edgar was conditioned by the exile of their father. They had both been born in Hungary (Ronay 1989), where the proximity of the fur-rich forests of Central Europe[21] must have been reflected in dress, a fashion perhaps maintained by the exiled family and their courtiers for some time after their return to England in 1057. Sadly, Prince Edgar almost immediately lost all of his gifts in a shipwreck. The chronicler tells us that Malcolm and Margaret gave him more gifts to make up for it, but, perhaps getting bored with one of history's losers, does not bother to list them.

Apart from these, our information about Old English words for fur or leather comes from Latin/Old English glosses.[22] Glossaries were writ-

ten to help people read Latin, not to help people learn Old English, but very often they are the only evidence we have, so provided we use them conservatively, we must look at them. Thus we find that a long fur garment might be called *crusene*, *fel* or *heden*, and that a *basing*, a *rocc* and a *sciccels* could also be fur (but need not be). We do not always know if the English actually had garments called by these names, or if they were adapting English terminology to the demands of the Latin texts they were trying to translate. Thus, in a list of clothing names, Latin *mastruga*, 'a sheepskin', is glossed *crusene oððe deorfellen roc* (Wright 1884: 328, l.11), 'crusen or animal skin garment'. *Rocc* is an interesting word because it has survived in modern European languages as a garment name, though its meaning has undergone several variations. In current Dutch and German it means a skirt, but in older German usage it could signify a coat, or even a dress. The Anglo-Saxon *rocc* evidently covered the chest, because in a glossary list of garments we find Latin *renones* (the *reno* of Caesar and Isidor) glossed by Old English *stiðe and ruge breostrocces* (Wright 1884: 151, l.39), 'stiff and rough breast-garments'. Certainly a *rocc* could be made of fur or skin. In another gloss Latin *melotes, uel pera* is rendered *gæten uel broccen rocc* (Wright 1884: 152, l.1), 'goatskin or badgerskin garment'.

Hair or skin garments might be adopted for penitential reasons[23] but they might also be worn for comfort. Correspondence between clergy records the gift of an otter skin garment, perhaps, from the terms of the letter, a luxury item, and called in Latin *gunna*. It was sent to the eighth-century missionary Lull by Cuthbert of Wearmouth and Jarrow, in Northumbria.[24] There are still otter-hounds, if regrettably few otters, in present-day Northumberland; probably the garment was a product of the area. The *gunna* could, apparently, be short,[25] and was perhaps normally made from the skins of readily available farm animals, since *gunna* is glossed by the Old English word *heden* in the *Corpus Glossary* (Lindsay 1921: 87, G.185) and *heden* elsewhere renders Latin *melote* (Napier 1900: 39, l.1471), 'an animal skin, particularly sheepskin, or goat'.

The garment is perhaps the same as that referred to as *fel* in an Old English monastic rule. *Fel* normally means 'skin', sometimes human but usually animal, but in this unique instance, where it renders *pelle* in the Latin version, context suggests a garment. 'Some priests', we are told, commit the sin that 'their *fel* hangs down so far that the foot does not show'.[26] One gets the impression of a long cosy garment, keeping the legs and feet warm during those long stints of prayer; but if the fur garment was usually short, this could have been seen as wickedly luxurious.

Charlemagne, the Frankish king who corresponded with the English king Offa, and traded English cloaks for stone (Haddan and Stubbs 1869–78: III, 497) was particular about his clothing. He liked it warm and practical, and he liked it traditional, as his biographer Einhard tells us. As the Franks were very close to the Anglo-Saxons both geographically and culturally, it is worth concluding with a look at what he liked to wear. He dressed in a linen shirt and pants, hose and a silk-edged tunic, presumably of wool. In winter he protected his chest and shoulders with a *thorax* of otterskins and/or ermine. In addition he wore a blue cloak.[27] The fur garment, then, was not his cloak. Latin *thorax*, although most familiar in the sense of 'breast plate', 'cuirass', is also documented in the sense 'doublet' (Lewis and Short 1897). Presumably the biographer, in using this word for a fur garment, meant a kind of jerkin. It may be relevant that Old High German *brust-roch*, cognate to Old English *breostrocc*, glosses *thorax*.[28] As we have already seen, *stiðe and ruge breostrocces* glosses *renones* (Wright 1884: 151, l.39).

It seems possible that there was a continuity in the use of a fur jerkin among the Germanic people, from ancient times, when Roman observers called it *reno*, to the era of Charlemagne about nine hundred years later, when it was called in Latin *thorax*; and that the Anglo-Saxons, although they did not depict it in art, also used such a garment, which they called in Latin *gunna*, and in their own language *rocc* or *heden*.

Acknowledgements

I wish to thank Christina Buthe, Carolyn Farrer and Maria FitzGerald for bibliographical support in preparation of this article and Arthur MacGregor for information on the habitat of reindeer.

Notes

1. '*se consuetudinem adduxerunt ut locis figidissimis neque vestitus praeter pelles haberent quidquam, quarum propter exiguitatem magna est corporis pars aperta*'('they have regularly trained themselves to wear nothing, even in the coldest localities, except skins, the scantiness of which leaves a great part of the body bare') (Edwards 1917: iv, 1, 182, 183).
2. Definitions of *reno* in reputable Latin dictionaries are unhelpful. The Lewis and Short definition, 'a reindeer skin, as a garment of the ancient Germans a fur pelisse', is both tautologous and archaic 'pelisse' being a derivative of Latin *pellicia* and hence

meaning a skin, and also being the name of a modern (eighteenth-century), but now outmoded garment, originally fur-lined but ultimately not necessarily so (Lewis and Short 1897). The Oxford definition, 'reindeer skin or a garment made from it', is vague (Glare 1980: fascicle vii). Cassell's 'a garment made of fur', is vaguer still (Simpson 1968).

3. *'gerunt et ferarum pelles, proximi ripae neglegenter, ulteriores exquisitius, ut quibus nullus per commercia cultus. eligunt feras et detracta velamina spargunt maculis pellibusque beluarum, quas exterior Oceanus atque ignotum mare gignit.'* ('They wear also the skins of wild beasts, the tribes adjoining the river-bank in casual fashion, the further tribes with more attention, since they cannot depend on traders for clothing. The beasts for this purpose are selected, and the hides so taken are chequered with the pied skins of the creatures native to the outer ocean and its unknown waters.') (Peterson and Hutton 1914: *Germania* 17, 288, 289).

4. The grey seal is perhaps too confined to coastal waters, but the North Atlantic harp seal, with its irregular black patches on a white coat, would be a striking example. The hooded seal, with its blotches or spots, might also be a candidate, and perhaps even the bearded seal, which frequents the icy polar waters. I am grateful to Peter Crocker for this information.

5. It is not within the scope of this paper to consider archaeological evidence in detail. In brief, there is evidence of leather belts from pagan graves but only rare possibilities of fur from this source. Later Anglo-Saxon and Anglo-Viking urban sites have produced leather shoes.

6. In fact the saddlecloth, although obviously skin, bears little resemblance to the ostentatious, bushy, lion pelt of the text; it looks very similar to other numnahs, probably meant to be sheepskins, which appear without textual prompting in other Anglo-Saxon manuscripts and which may reflect contemporary fashion (Atherton 1990: 41–2; the sheepskins appear in scenes 3 and 4; Dodwell and Clemoes 1974: fos 25r, 51r). I am grateful to Mark Atherton and Shelagh Aston for discussing this material.

7. British Library, MS Harley 603.

8. British Library, MS Cotton Julius A vi, fo. 6.

9. The possibility of leather was suggested by Nevinson (1947: 72). He discussed the costume of Guy together with those of Odo and the figure identified as William and considered they were wearing the same kind of garment, describing it as 'probably a military coat or rather tunic ... it looks as if it was padded and quilted ... Its ground material was presumably linen, and if the variegated texture indicates that some of the quilted surface was reinforced with leather, it would have formed quite an effective defence in battle'. I would argue that Guy's garment is different from the others.

10. Although he rides near the front of the procession (he is the third rider), his horse is overlapped by the following one, so he is unlikely to be William, who, when present, normally occupies the foreground in the Tapestry. In this scene the foreground position is taken by a figure immediately beneath the name Willem Dux and by an elaborately armed figure carrying William's distinctive cross-standard. One of these probably represents William; I would suggest the armed man.

11. Later Anglo-Saxons seem to have assumed this. Latin *galliculae* is glossed by Old English *scos*, 'shoes' in a Latin–Old English word list (Wright 1884: col. 414, l.31). *Calicula* is glossed by Old English *socc*, 'a loose footcovering' in another glossary (Kindschi 1955: 88).

12. *Old English Concordance*, microfiche (1980), University of Delaware.

13. *The Complete Corpus of Old English on Machine Readable Form*, Dictionary of Old English Project, Centre for Medieval Studies, University of Toronto; on WordCruncher, software from Brigham Young University.
14. As an example of the potential complexity, I list some alternates for the Old English word *sciccels* ('a cloak', possible sometimes fur): *sciccel, sciccels, sciccelse, sciccing, scicelse, scicging, scicilse, scicing*.
15. Lappish tribute to the Norse included *berenne kyrtel oððe yterenne* (Sweet 1883: 18, l.21).
16. Actual date 1074.
17. The king's prefect had first right of purchase on any cargoes of marten skins (*martrinas pelles*) imported into the city (item 1a) and three timbres of marten skins (3 × 40 pelts) were paid by Chester annually to the earl and king.
18. **Pilch** 1. A triangular flannel wrapper worn by infants (citations suggest this is what we would call a napkin or diaper); and 3. Anything hung before the thighs to protect them from injury (Wright 1903). Personal discussion with several English women suggests the word was until recently applied to a pair of pants designed to keep a baby's napkin in place. I am grateful to Frances Owen for pointing out this usage.
19. I am grateful to Professor Jane Roberts and the *Thesaurus* project for this information.
20. Despite the word division in WordCruncher, *hearm ascynnene*, the Old English headword cannot be *hearm*, 'damage', but *hearma*, which is less well documented. WordCruncher gives four citations where it glosses Latin *megale* (presumably for *mygale*, 'a small species of mouse'). There are cognates in Old High German, *hermil, harmil* (Karge-Gasterstädt and Frings 1968–in progress), and in modern German, *Hermelin*. I am grateful to Dr Veronica Kniesza for pointing out these cognates.
21. See 'Trading in fur, from classical antiquity to the Middle Ages', J. Howard-Johnston, this volume, pp.65–79.
22. Glosses came into existence when people reading texts in Latin added their own notes to explain them, writing in an equivalent word, or words, often in Latin but sometimes in Old English, in a convenient space in the margin of the text or between the lines. Glosses were later collected into word lists, and still later into glossaries arranged in order of subject or according to simple alphabetical principles, thus taking the words out of context. Many dictionary citations of Old English words derive from glosses. In such cases, an Old English word is documented in a manuscript, and, since it glosses a known Latin word, its meaning is known; but unless it occurs elsewhere, one does not know if it was in common use or a *hapax legomenon*, nor the full extent of its semantic range. Alternatively the same Old English word may gloss more than one Latin lemma with different meanings.
23. In a penitential piece attributed by Napier to Archbishop Wulfstan, people were urged to wear hair or wool at times of national disaster (Napier 1883: 70, ll.9–10). The hermit St Guthlac chose skin garments rather than either linen or wool (Colgrave 1956: 94).
24. *Gunnam de pellibus lutraram factam* (Tangl 1916: 116, p.251, ll.14–15).
25. *Gunnam brevem nostro more consutam*; 'a short *gunna* stitched according to our custom' (Tangl 1916: 114, p.247, ll.21–2).
26. *heora fell swa wide hangion þæt se fot ne ætywe* (Napier 1916: 64, l.31).
27. *Vita*, para 23 (Pertz 1829: 455, ll.32–5). The description specific to fur garments is: *ex pellibus lutrinis et murinis thorace confecto humeros ac pectus hyeme muniebat*.
28. *Brustroc, prustroc* (Karge-Gasterstädt and Frings 1968–in progress).

References

Amos, A. C., di Paolo Healey, A., Holland, J., Franzen, C., McDougall, D., McDougall, I., Spiers, N., Thompson, P. (1986–in progress) *Dictionary of Old English*, Toronto.

Atherton, M. (1990) *Innovations in the illustrations of an Anglo-Saxon manuscript of Prudentius'* Psychomachia *in the British Library: Cotton MS Cleopatra C viii*, unpublished MA thesis, University of York.

Beamont, W. (1863) *A Literal Extension and Translation of the Domesday Book relating to Cheshire and Lancashire*, Chester.

Bosworth, J. and Toller, T. N. (eds) (1972) *An Anglo-Saxon Dictionary and Supplement*, with enlarged Corrigenda and Addenda by A. Campbell, 2 vols, London.

Bouterwek, C. W. (ed.) (1858) *Screadunga*, Elberfeld.

Colgrave, B. (ed.) (1956) *Felix's Life of Saint Guthlac*, Cambridge.

Dodwell, C. R. and Clemoes, P. (1974) *The Old English Illustrated Hexateuch*, Early English Manuscripts in Facsimile 18, Copenhagen.

Du Cange, C. D. F. (1883–87) *Glossarium Mediae et Infimae Latinitatis*, with supplements, edited and revised by L. Faure, Niort.

Edwards, H. J. (trans.) (1917) *Caesar The Gallic War*, Loeb Classical Library, London.

Garmonsway, G. N. (trans.) (1954) *The Anglo-Saxon Chronicle*, 2nd edn, London.

Glare, P. G. W. (ed.) (1980) *Oxford Latin Dictionary*, fascicle vii, Oxford.

Haddan, A. W. and Stubbs, W. (1869–78) *Councils and Ecclesiastical Documents relating to Great Britain and Ireland* 3 vols, Oxford.

Hald, M. (1980) *Ancient Danish Textiles from Bogs and Burials*, J. Olsen (trans.), English edn, National Museum of Denmark, Archaeological-Historical Series, 21, Copenhagen.

Jackson, K. H. (ed.) (1969) *The Gododdin: the oldest Scottish poem*, Edinburgh.

Karge-Gasterstädt, E. and Frings, T. (1968–in progress), *Althochdeutsches Wörterbuch*, Berlin.

Kindschi, L. (1955) *The Latin–Old English glosses in Plantin-Moretus MS 32 and BM MS Additional 32, 246*, unpublished PhD thesis, Stanford University, University Microfilms, Doctoral Dissertation Series No.15,375, Ann Arbor, Michigan.

Lewis, C. T. and Short, C. (eds) (1897) *A Latin Dictionary*, 1973 impression, Oxford.

Lindsay, W. M. (ed.) (1911) *Isidori Hispalensis Episcopi Etymologiarum sive Originum*, 2 vols, Oxford.

Lindsay, W. M. (ed.) (1921) *The Corpus Glossary*, Cambridge.

Napier, A. S. (ed.) (1883) *Wulfstan*, Berlin.

Napier, A. S. (ed.) (1900) *Old English Glosses*, Anecdota Oxoniensia, Medieval and Modern Series, 11, Oxford.

Napier, A. S. (ed.) (1916) *The Old English version of the enlarged Rule of Chrodegang*, Early English Text Society, original series, 150, London.

Nevinson, J. L. (1947) 'The Costumes', in *The Bayeux Tapestry*, Sir F. M. Stenton (ed.), 2nd edn, London, 70–75.

Owen, G. R. (1976) *Anglo-Saxon Costume*, unpublished PhD thesis, 3 vols, University of Newcastle upon Tyne.

Owen, G. R. (1979) 'Wynflæd's wardrobe', *Anglo-Saxon England* **8**, 195–222.

Owen-Crocker, G. R. (1986) *Dress in Anglo-Saxon England*, Manchester.

Owen-Crocker, G. R. (1994) 'The Bayeux "Tapestry": Culottes, Tunics and Garters, and the Making of the Hanging', *Costume* **28**, 1–9.

Pertz, G. H. (ed.) (1829) *Monumenta Germaniae Historica, Scriptores* 7, II, Berlin.

Peterson, W. and Hutton, M. (trans.) (1914) *Tacitus Dialogues Agricola Germania*, Loeb Classical Library, London.

Plummer, C. and Earle, J. (eds) (1892–3) *Two Anglo-Saxon Chronicles Parallel*, 2 vols, Oxford.

Roberts, J. and Kay, C. with Grundy, L. (1995) *A Thesaurus of Old English*, King's College London Medieval Studies 11, London.

Ronay, G. (1989) *The Lost King of England*, Woodbridge.

Savage, A. (trans. and collated) (1982) *The Anglo-Saxon Chronicles*, London.

Simpson, D. P. (ed.) (1968) *Cassell's New Latin-English English-Latin Dictionary*, 5th edn, London.

Sweet, H. (ed.) (1883) *King Alfred's Orosius*, Early English Text Society, original series 79, London.

Tangl, M. (1916) *S. Bonifatii et Lulli Epistolae, Monumenta Germaniae Historica, Epistolae 4, Epistolae Selectae*, I, Berlin.

Veale, E. M. (1966) *The English Fur Trade in the Middle Ages*, Oxford.

Whitelock, D. (ed. and trans.) (1930) *Anglo-Saxon Wills*, Cambridge.

Wilson, D. M. (1985) *The Bayeux Tapestry*, London.

Wright, J. (1903) *The English Dialect Dictionary* **4**, Oxford.

Wright, T. (ed.) (1884) *Anglo-Saxon and Old English vocabularies*, 2nd edn, collated by R. P. Wülcker, 2 vols, London, reprinted Darmstadt (1968).

♦4♦

Pre-conquest Leather on English Book-bindings, Arms and Armour, AD400–1100

Esther Cameron

It is a curious fact that objects of leather dating from AD400–600 identified from any English context, archaeological or otherwise, are extremely rare. No shoe fragments survive, and traces of mineralised skin on weaponry from cemeteries of this date (characteristically thin and applied to wood) may well have been of rawhide. Remains of a rectangular leather container for a balance and set of weights, dated to the first half of the sixth century, from Watchfield, Oxfordshire, is an exceptional find from an unusual grave containing several objects possibly imported from Merovingian Gaul (Scull 1986).

Vegetable tanned leather, manufactured and widely used in the Roman world, may have played an essential role in the everyday life of peoples from North West Germany and Jutland before their settlement of Britain but the evidence for this needs to be re-examined. The purpose of this paper is to review the forms (other than footwear) in which leather survives in England from the fifth century to the Norman conquest. This starts with book-bindings and leather-working techniques used in their production, and then considers aspects of leather usage for arms and armour from the seventh century through to the mid-eleventh century.

The earliest surviving book-bindings in northwestern Europe, the Stoneyhurst *Gospel of St John* in the British Library and the *Cadmug Codex* in the Landesbibliothek at Fulda, West Germany, are thought to be English (Nixon and Foot 1992: 1–3) and to emulate a distinctive East Mediterranean (Coptic) style of book production, which endured in Europe until the late seventh century. A third English binding, the *Codex Bonifatianus I*, which is also at Fulda, and dated to the late seventh

or early eighth century, stands as a symbol of important changes that took place in book bindings at that time. After AD700 East Mediterranean influence upon northwest European book production seems to have ceased; an individual style and technique then evolved, within which some original Coptic elements remained embedded (Wilson 1961: 214). The remarkable survival of these ancient bindings offers an unparalleled source of comparative material, a template against which archaeological evidence can be compared, both in order to interpret remains accurately and to build up a recognisable picture of Anglo-Saxon leathercraft.

Other English bindings dating from the later part of the eighth century through to the eleventh century survive in less complete form: their wooden boards have been stripped of the original leather and re-covered at later dates. The Tudor rebinding of *The Domesday Book* is one such example and there are several others identified in the Bodleian Library (Pollard 1975). Dateable leather covers of this period are unknown until a series of stamped bindings emerges in the twelfth century.

The use of leather in Coptic style bindings

Coptic style books were made from leaves of parchment or papyrus, folded in groups (quires), and sewn together with threads made from vegetable fibre. They were bound between thin wooden boards or boards made up of many layers of papyrus glued together and covered with a thin sheet of leather. Leather covers of Coptic bindings, such as those of the ninth century from Kairouan, Tunisia, exhibit slit and thread decoration, relief moulding, and stamped designs. Some Coptic style books were secured when shut with leather thongs tied around the bindings, but more commonly closure pegs of metal or bone were rooted in the edge of the lower cover, to which a loop of braided thong from the upper cover could be fastened (Petersen 1954).

The small and elegant bindings of the Stoneyhurst Gospel and *Cadmug Codex*, made from thin wooden boards covered with leather, glued or pasted, clearly belong to this tradition. The so-called Stoneyhurst Gospel was discovered in the coffin of St Cuthbert, whose first interment at Lindisfarne in 687 (later at Durham), is documented by Bede (Colgrave 1940). The binding of this delightful volume has birch boards, 2.5mm thick, covered with vegetable-tanned sheep or goat skin (Brown 1969), decorated with designs executed in relief moulding,

tooling and paint. Parchment quires were sewn to each other with thread using chainstitch and secured to the boards by sewing into holes pierced at the spine edge. Head bands decorating the top and bottom of the spines were also stitched and attached to the boards through corner holes, each thread consisting of four fine strands of S-spun white flax. The strands are used together but are not plyed (Brown 1969).

Details of the binding of the *Cadmug Codex* (van Regemorter 1949) show that it is closely linked in style and construction to the binding of the Stoneyhurst Gospel.

Romanesque bindings

In the *Codex Bonifatianus I* at Fulda, regarded as the earliest extant product of the new northwestern school of book binding, some superficial differences in the binding are immediately obvious. One is the density and thickness of the wooden boards, in this case 6mm of oak. The overall dimensions of this book, being greater than either the Stoneyhurst Gospel or the *Cadmug Codex*, require a board of greater substance, but even so, thick boards become one of the hallmarks of Anglo-Saxon book production. The use of oak for Anglo-Saxon book boards is remarkable in its consistency: seven Anglo-Saxon boards in the Bodleian Library and British Library, dating from the early eighth to the early eleventh centuries, have been identified as oak (Pollard 1975) and the book boards of the original *Domesday Book* (1086), were also of oak (Forde 1986). Powell (Battiscombe 1956) mentions beech and poplar as woods used for medieval book boards, but unfortunately offers no examples. Boards for books, with the wood-grain running in a radial-longitudinal direction, were shaped with adze and plane and (until the mid-twelfth century or a little later) their edges square-cut to lie flush with the leaves of parchment. It is not known if covers were pasted to boards, but an adhesive was used to attach a vellum lining to the boards of the *Codex Bonifatianus I* (Wilson 1961).

The manner in which quires of Romanesque books were stitched and joined as well as the technique of attachment to the boards differs, but can be seen to have developed from the Coptic style. From about 700 to 1000 the northwest European quire was sewn on to cords of twisted vegetable fibre which crossed the spine of the book and after AD1000 double thongs of alum tawed skin were used instead of cords. Both the cords and the later thongs were threaded into the boards through tunnels

bored into the edge using a gimlet. Tunnels emerged from the boards on either the inner or outer surfaces, where they continued as grooves before terminating in a hole. After passing through the tunnels and along the grooves, cords were fixed at the last hole with a wooden dowel. Protruding dowels and cords were removed with a chisel (Pollard 1962, 1975). This system of tunnels and grooves, demonstrated by radiography to follow a triangular route, is characteristically Anglo-Saxon. The cords of the *Codex Bonifatianus I*, which are used double across the spine of the book, divide into sections inside each of the boards and are twisted together again where they rejoin (Wilson 1961). A similar tunnelling technique used in different threading patterns continues after the conquest into the first quarter of the thirteenth century. The use of flat, strap-like supports of alum tawed skin led to a change in the shape of the tunnels and grooves cut into the boards, and to the use of wedges, rather than dowels or pegs (Pickwoad pers. comm.).

With the exception of the *Codex Bonifatianus I* there is no material evidence to suggest that Anglo-Saxon books had metal clasps, and X-rays of Anglo-Saxon book boards show no sign of such fittings ever having been attached (Pollard 1975).

Leather working and decorative techniques

Extremely sharp knives are required for cutting leather but none that is specific to shoe-making, cobbling or other forms of leathercraft have been identified from the archaeological record. Manuscript illustrations suggest that semicircular bladed knives were used, but no medieval examples have been found. Medieval illustrations of shoe-makers at work also feature shears of slightly differing styles which may have been used to cut thinner leathers made from small or very young animals. Awls, for piercing leather, are traditionally diamond shaped in cross-section. Four such awls dating from the tenth century to early in the twelfth century have been found in London (Vince 1991) and a further eighteen awls come from tenth century contexts at Coppergate, York (Ottaway 1992).

Dampened leather can be impressed with blunt or sharp instruments to produce decorative work sometimes called tooling. From Coppergate come a small series of double-armed leather creasers, used to impress a line along the edge of the leather to decorate it and lessen any tendency to fray. They were heated and applied to damp leather, one of the arms acting as a guide at the leather edge. In cross-section the working tips are

either triangular or rectangular. Apart from these, no tools specific to this purpose and of early medieval date have been found, although some examples of bone and wood and of Roman manufacture are known. A good example of tooling on Anglo-Saxon leather is to be seen on the binding of the Stoneyhurst Gospel where it is used to accentuate raised moulded lines and to execute a border and two panels of interlace on the front face. The impressed lines are highlighted with pigment. On the front cover of the same binding is figured a vine-leaf scroll, which stands out in relief. This was achieved by using a technique known as foundation moulding, which involves glueing cords or thongs on to a wooden board and covering them with leather to produce a repoussé effect. Foundation moulding is thought to be a technique adopted from the East Mediterranean, although, paradoxically, the Stoneyhurst moulding is executed with an experienced hand and predates any equivalent examples in Egypt and Tunisia. A fragment of painted red parchment, however, found in Cairo and broadly contemporary with the Stoneyhurst binding, was backed by a coarse linen textile to which strings had been glued, adding weight to the supposition that foundation moulding originated in Egypt (Ettinghausen 1984).

The decoration of leather book covers by stamping was an early Coptic technique. Only one English example of stamped leather predates the twelfth century and this is to be found on the binding of the *Codex Bonifatianus I*. Although the design of its stamps and the pattern of their layout appear wholly foreign to eighth century insular styles, Wilson believes the work to be English, albeit under strong East Mediterranean influence. Following this there is no English stamped leather until the mid-twelfth century, when a series of stamped bindings emerge, probably from Winchester, London and Durham (Nixon and Foot 1992). This suggests that stamping never became part of the Anglo-Saxon repertoire, and an Anglo-Saxon 'book-binder's stamp', found in a garden in Swanley, Kent and now in the British Museum, is regarded by this author as dubious.

No dye has been detected in leather of pre-conquest date from an archaeological context. The seventh-century book-binding of the Stoneyhurst Gospel is, however, dyed a deep red colour and that of the *Codex Bonifatianus I* is also red (Wilson 1961). For special ecclesiastical purposes vellum was dyed purple and written upon in silver or gold ink, and such a book was commissioned by Bishop Wilfred.[1] Alum, a mordant widely used in southern Europe to produce bright colours, was probably imported into Roman Britain since there were few insular sources. But certain club-mosses native to the British Isles make suitable

alum type mordants and have been found to produce bright crimson reds with madder dye. Club-mosses may have been a mordant source for the Anglo-Saxons and were certainly used by Anglo-Scandinavians at York (Hall *et al.* 1984). Madder (red) and woad (blue) were both cultivated in Britain before the conquest, and a purple dye was available from native lichens. A different source of purple, from shellfish (*Purpura lapillus* L.), belongs to Irish tradition and is mentioned by Bede. Red and purple dyes obtained from madder and lichen were detected on textiles dating from the late sixth century to the mid seventh-century from burials at Sutton Hoo, Taplow, Chessell Down, Kempston and Broomfield (Taylor 1990).

Pigments of blue (or silver) and yellow adorn the front cover of the Stoneyhurst Gospel binding while its contemporary, the *Cadmug Codex*, has tooled lines on the cover that have been coloured with gold. Theophilus, the German author of a twelfth-century Latin text *De Diversis Artibus*, commenting upon the application of ground gold to vellum, speaks of glair (egg white) as an adhesive. Paints for manuscript illumination were made from ground pigments mixed with gum often in seashells for the illustrator to hold, and surviving pallette shells containing pigment have been found at Glastonbury (Gameson pers. comm.).

While early bindings of Coptic tradition certainly used adhesives, it is not known if the covers of later Saxon bindings were glued or pasted to the boards. They may have been held by mitred and stitched corners. With the exception of birch-bark pitch or tar, pine resins, beeswax and flour paste, adhesives available to the Anglo-Saxons were of animal-derived protein and have not survived burial or the passage of time. Casein, obtained from milk or cheese, is mentioned by Theophilus as a wood glue for altar panels and doors as well as for covering shields with leather. Gelatin, from the skin and bones of animals and fish, was a general purpose, water-soluble glue for leather and composite constructions. The original binding of the *Winton Domesday*, dated to the mid twelfth-century, included two very unusual 'boards' made up by pasting together vellum leaves from an older book, but the leaves were separated and rebound in the eighteenth century without a record being made of glue or paste remains (Brown *et al.* 1976).

Arms and Armour

In view of the scarcity of archaeological evidence for Saxon leather-working it is not surprising that largely unsupported assumptions about

its use have become established in the literature. One such assumption relates to the wearing of body armour. Body armour known to have been worn by the Anglo-Saxons includes mail shirts and helmets. Such items are described in the literature of the period, illustrated in the Bayeux Tapestry and supported by archaeological evidence. In addition to this it is suspected that another form of body armour, the muscled cuirass, was used by the Anglo-Saxon elite. The muscled cuirass has a long pedigree and early Greek and Etruscan metal examples survive to this day. As depicted in Roman figuative art, it was worn by distinguished military leaders, and is thought to have continued in use into the fourth and fifth centuries. This sleeveless piece of body armour covered the front and back torso and was fastened at the sides and shoulders with a distinctive form of clasp. The discovery of shoulder clasps in the ship burial at Sutton Hoo and a possible second pair from a grave at Taplow (Bruce-Mitford 1978: Figs 441a, 343, pl.22b) suggests that a cuirass, or a substantial substitute for one, was regarded as an important part of princely regalia. This in itself presents no problem, but in discussing the clasps from Sutton Hoo, Bruce-Mitford (1978: 523–35) assumes that the Roman muscled cuirass was made from moulded leather. This widely held view rests upon Roman artistic convention and in particular on depictions of soldiers apparently wearing leather armour, a view strongly challenged by Coulston (1990), who argues that the convention previously understood to convey the wearing of leather was really for mail. The clasps, then, no doubt adopted from Late Roman tradition, were associated with some sort of body armour; the material used is still open to question.

The Sutton Hoo shoulder clasps were not attached to a metal cuirass, and it is clear from their fastenings that they were never meant to be. The position of the clasps in relation to the supposed body and to each other provide some clues to the nature of the material. The clasps were not found at the shoulders but offset to one side, 25cm apart, orientated in opposite directions, with one face up, and the other on edge. The Taplow clasps were also offset from the body,[2] at about waist height and probably very close together, a circumstance that led to them being described at first as fittings for a double belt. The position of the clasps gives us two pieces of information. Firstly, the garments they fastened may not have been worn by the corpse, but may have been placed or suspended nearby in their respective burial chambers. Secondly, unless the clasps had been detached prior to their deposition the garments they adorned are likely to have been flexible. Although ordinary thin leathers are not ruled out, this precludes the use of thick hide, or of rigid, hardened *cuir bouilli* (see below).

A distinctive feature of these clasps is the presence of numerous metal loops or staples on the back, which on the Sutton Hoo clasps protrude by 4mm, leaving an internal opening of 2mm. As a means of attaching metal to an organic material this is unusual. Rivets were normally used for joining leather to metal and would have been effective in this case. I would suggest that the garment was one of textile, probably padded, and that it would have been worn over several layers of clothing, or at least another equally thick layer, in order to have relieved the shoulders of the wearer from the discomfort of the staples, and that the clasps and garment were joined by stitching.[3]

Cuir bouilli is a term used for leather that has been moulded into a shape and hardened. Such leather is tough, durable, light-weight and retains its shape permanently. It has been suggested that *cuir bouilli*, a term that literally translates as 'boiled leather', required treatment with oil, hot wax or boiling water. The late John Waterer (1981: 62–77) proposed that moisture and a gentle drying heat were required, but recent experiments conducted by this author have demonstated this to be untrue. Types of objects traditionally made by *cuir bouilli* are either containers or are parts of armour. Anglo-Saxon containers, of both a domestic and ecclesiastical nature, probably included drinking cups and costrels, but none survive. A mid seventh-century drinking cup from Benty Grange, Derbyshire, originally described as having been made of leather, has never been verified and only the metal fittings remain. Post-Conquest bottles, jugs and buckets may have been made of hardened leather, and Winchester ware type–3 bottles curiously bear witness to this as tenth to eleventh century skeuomorphs (Biddle and Barclay 1974). By the fourteenth century, *cuir bouilli* is thought to have been used as plate armour for men and horses, and receives frequent mention in English documents, especially wills, of the fourteenth and fifteenth centuries (Kurath and Kuhn 1956), but unfortunately no pieces survive[4] and the exact meaning of this term remains uncertain. No examples of hardened leather have yet been recovered from an Anglo-Saxon context.

Skin or leather was used by the Anglo-Saxons on shields and sword scabbards as well as for knife sheaths. Anglo-Saxon shields were made of wood and covered with leather or skin. Shield boards, with an average diameter of 60cm and a thickness of 0.75cm, show a chronological trend from the smallest and thinnest in the fifth century to the largest and thickest in the late seventh century (Dickinson and Härke 1992). Leather, used to cover the boards, has in all cases been insufficiently preserved for identification. The use of sheepskin, which is thin and weak, on shields was forbidden by a tenth-century law of Athelstan

(Whitelock 1979), and Theophilus specifies the use of untanned horse, ass or cow hides 'soaked in water until the hairs can be scraped off'. Mineralised skin or leather remains on shield fittings lead us to believe that both sides of the board were covered, but whether it was attached by glue or secured by stitching, by metal studs or by shrinking on from the wet state remains a matter for speculation. According to Theophilus, the wet hide was stuck to the board with casein glue. Functions of the shield board cover, other than imparting strength and protection, might have been decorative or emblematic – Continental examples of painted shield boards of the Late Roman Iron Age as well as of Viking date are known (Dickinson and Härke 1992: 54). Another feature of some shields may have been a thickened rim, such as that illustrated on the Repton Stone (Biddle and Kjølbye-Biddle 1991), which could have been produced by an underlay or by a stitched overlay of leather. Remains of leather straps or bindings are commonly found on shield grips.

Sword scabbards of wood were fleece-lined and covered with leather. Since the lining was not for display, reasons for its selection are likely to have been practical and therefore it is not surprising to find that lining hairs that have been scientifically identified[5] are invariably of sheep. Lamb skin was abundant; it was of the right size, of suitable springiness to support the sword, and its natural grease (lanolin) provided excellent waterproofing to help prevent rust upon the blade. Scabbard covers were tight-fitting, but it is not known what sort of leather was used in the fifth to sixth centuries. Surviving traces examined by this author indicate that thin, or shaved-down skins were used in association with various features that stand out in relief on the front scabbard face. These are, for the most part, linear designs executed both in the wood, and by the application of twisted cord to the wooden surface to produce a raised effect in the finely moulded leather, possibly applied with adhesive. Examples of the use of cords beneath leather survive on sword scabbard fragments from the cemetery of Howletts, Kent and on the scabbard of a sword from the seventh-century chamber grave at Broomfield, Essex. The wooden surface of the sword scabbard from Morningthorpe, Suffolk, was possibly carved to produce, in cross-section, a crenellated effect (Cameron, in preparation) similar to a late fifth-century example seen by this author after its recent discovery in waterlogged deposits at Nydam, Denmark. Both techniques, clearly related to the foundation moulding displayed upon the front cover of the Stoneyhurst gospel, are Late Roman in origin. Another survival of Late Roman technique, the application of gold directly on to a leather surface, occurs on a seventh-century sword scabbard from Mucking, Essex (Hurst, in preparation).

There is some evidence to suggest that the thickness of leather used for scabbard covers increased during the course of the seventh century and required stitched seams such as those recorded by this author on two swords in the British Museum, from Tissington, Derbyshire and Broomfield, Essex, both of which show thongs used in a serpentine stitch.

A group of knife sheaths belonging to the late sixth and early seventh centuries, found at Snape, Suffolk, and studied by the present author, were made from 1.5mm thick leather (three identified as bovid), tunnel-stitched with thong, and one decorated with incised lines. The sheaths also extended over the handles of the knives (Fell 1996).

During the seventh century single-edged weapons called seaxes appeared in England. These were carried horizontally, suspended from the waist, in substantial leather sheaths decorated with incised lines and fitted with metal studs and nails. Mineralised remains of seax sheaths from Middle Saxon cemetery sites at Castledyke, South Humberside (Edwards and Watson 1993), Harford Farm, Norfolk (Watson 1992) and Buttermarket, Ipswich (Scull, in preparation) provide useful information in details of construction and design, but we cannot be sure at this stage that they are not imports from the Lower Rhineland where a similar group is distributed.

A later group of seax sheaths thought to date to the tenth century and found at London, Gloucester, Hexham and York, are highly decorated with deeply impressed designs accentuated by tooled lines, and seamed by tunnel stitch reinforced with metal rivets. Their relationship to earlier Anglo-Saxon leather-work has not been established and it must be assumed that they were either imported by the Anglo-Scandinavian community or were produced locally for that market. Knife sheaths of similar date from Coppergate, York, also examined by this author, are made almost exclusively from calf, usually tooled but occasionally incised and sometimes moulded. Scabbard covers dating from the tenth century from Gloucester and York are made from undecorated calf, 1–2mm thick, with butted seams stitched with thong.

Conclusion

Anglo-Saxon leather-work does not show evidence of any definable Germanic origins but seems rather to have been rooted in Late Roman tradition using extremely thin skin products over a wooden foundation with decoration raised in relief and emphasised by colour. Evidence

from cemetery finds suggests that a more robust form of leather-work was introduced in the seventh century, using thicker leathers that required stitching rather than glueing, that did not always need a wooden foundation and that was more easily decorated by tooling and incision. The strongest influences in style and techniques of leather-working from the eighth century to the eleventh century seem to have come from Southern Scandinavia and it is probably from this northern source that the English medieval leather-working tradition developed.

Acknowledgement

This text has been read in part or whole by Martin Biddle, Arthur MacGregor, Helena Hamerow and Nicholas Pickwood, each of whom made valuable comments and corrections, for which I am very grateful.

Notes

1. Concerning the building of the church at Ripon and its dedication (AD671–8); 'For he had ordered, for the good of his soul, the four gospels to be written out in letters of purest gold on purpled parchment and illuminated.' (Colgrave 1927: ch.xvii).
2. I am grateful to Lesley Webster and Katherine East for allowing me to examine a copy of the nineteenth-century grave plan of Taplow.
3. According to nineteenth-century reports the clasps from Taplow were found surrounded by layers of textile.
4. A fifteenth-century horse crupper in the collections of the Royal Armouries, previously cited as *cuir bouilli* (Waterer 1981), may not be so.
5. Based upon my own unpublished findings, also supported by several identifications of fleece linings at the Ancient Monuments Laboratory, London. I thank Jacqui Watson for this information.

References

Battiscombe, C. F. (1956) *The Relics of St Cuthbert*, Oxford.
Biddle, M. and Barclay, K. (1974) 'Winchester ware', in *Medieval Pottery from Excavations*, V. Evison, H. Hodges and J. G. Hurst (eds), London, 137–65.
Biddle, M. and Kjølbye-Biddle, B. (1991) 'The Repton Stone', *Anglo-Saxon England* **14**, 233–92.
Brown, T. J. (ed.) (1969) *The Stoneyhurst Gospel of St John*, Oxford.
Brown, T. J., Biddle, M., Nixon, H. M., and Wormald, F. (1976) 'The Manuscript of the

Winton Domesday', in *Winchester in the Early Middle Ages*, M. Biddle (ed.) Winchester Studies 1, Oxford, 520–49.

Bruce-Mitford, R. (1978) *The Sutton Hoo Ship Burial* 2, London.

Colgrave, B. (trans.) (1927) Eddius Stephanus's *Life of St Wilfred*, Cambridge.

Colgrave, B. (trans.) (1940) 'Bede's Life of St Cuthbert', in *Two Lives of St Cuthbert*, Cambridge.

Coulston, J. C. N. (1990) 'Later Roman Armour, 3rd–6th centuries AD', *Journal of Roman Military Equipment Studies* **1**, 139–60.

Dikinson, T. and Härke, H. (1992) *Early anglo-Saxon Shields*, Society of Antiquaries, London.

Edwards, G. and Watson, J. (1993) *Organic Material Associated with Metalwork from Castledyke, Barton, South Humberside*, Ancient Monuments Laboratory Report 74.

Ettinghausen, R. (1984) 'Foundation-moulded leatherwork – a rare Egyptian Technique also used in Britain', in *Islamic Art and Archaeology*, M. Rosen-ayalon (ed.), Berlin, 1161–9.

Fell, V. (compiler) (1996) *The Anglo-Saxon Cemetery at Snape, Suffolk: Scientific Analyses of the Artefacts and other Materials*, Ancient Monuments Laboratory Report 9.

Forde, H. (1986) *Domesday Preserved*, HMSO Public Record Office.

Hall, R. A., Hall, A. R., Taylor, G. W., Tomlinson, P. and Walton, P. (1984) 'Dyeplants from Viking York', *Antiquity* **58**, 57–60.

Kurath, H. and Kuhn, S. M. (eds) (1956) *Dictionary of Middle English*, University of Michigan.

Nixon, H. M. and Foot, M. M. (1992) *The History of Decorated Bookbinding in England*, Oxford.

Ottaway, P. (1992) *Anglo-Scandinavian Ironwork from 16–22 Coppergate*, The Archaeology of York, The Small Finds, 17.6, London.

Petersen, T. C. (1954) 'Early Islamic bookbindings and their Coptic relations', *Ars Orientalis* **1**, 41–64.

Pollard, G. (1962) 'The construction of English twelfth-century bindings', *The Library* fifth series, **17**(1), 1–22.

Pollard, G. (1975) 'Some Anglo-Saxon bookbindings' *The Book Collector* **24**, 130–59.

Scull, C. (1986) 'A sixth-century grave containing a balance and weights from Watchfield, Oxfordshire, England', *Germania* **64**, 105–38.

Speake, G. (1989), *A Saxon Bed Burial on Swallowcliffe Down*, London.

Taylor, G. W. (1990) 'Reds and purples: from the classical world to pre-conquest Britain', in *Textiles in Northern Archaeology*, P. Walton and J. Wild (eds), London, 37–46.

Theophilus, *De Diversis Artibus*, C. R. Dodwell (trans.) (1961).

van Regemorter, B. (1949) 'La reliure des manuscrits de S. Cuthbert et de S. Boniface' *Scriptorium* **3**, 45–51.

Vince, A. (ed.) (1991) *Aspects of Saxon and Norman London* 2, London and Middlesex Archaeology Society.

Waterer, J. (1981) *Leather and the Warrior*, Museum of Leathercraft, Northampton.

Watson, J. (1992) *Mineral Preserved Organic Material Associated with Metalwork from Harford Farm, Norfolk*, Ancient Monuments Laboratory Report 66.

Whitelock, D. (1979) 'Laws of Athelstan', *English Historical Documents* 1, London.

Wilson, D. M. (1961) 'An Anglo-Saxon bookbinding at Fulda (Codex Bonifatianus 1)' *The Antiquaries Journal* **41**, 199–217.

◆5◆

Leather Finds from Rouen and Saint-Denis, France

Véronique Montembault

In contrast with some other European countries, the preservation and especially the study of archaeological leather objects is a relatively new discipline in France. Such a discrepancy is not to be ascribed to the rarity of the finds but rather to ignorance of the information that could be gained through their study.

Some investigations have been carried out in the past few years, but few have led to publication. I am taking this opportunity to present work, mostly unpublished, on the leather finds from the archaeological site of Place de la Pucelle at Rouen, and from Saint-Denis near Paris.

The finds from Rouen

Important urban public works in 1993–95, and especially those for setting up the underground network, provided the opportunity for archaeological investigations at Rouen. To our knowledge, however, only those of the Place de la Pucelle, conducted from November 1993 to June 1994, have yielded leather articles.

The site, originally situated alongside the River Seine and limited to the west by a small stream, was for a long time outside the walls of the Roman and medieval town. The plot of land, crossed by a path, was occupied during the first centuries by a dispersed settlement. At the end of the second and beginning of the third centuries AD some buildings were established, to be replaced later on in the eleventh and twelfth centuries by a denser settlement consisting of blocks of houses.

Leather finds from contexts dated from the second century to the fifteenth century are mainly shoe fragments, and mostly soles. Irrespective of the period under scrutiny, the impression is that the items had not been deliberately discarded but merely been lost along the way or had been sucked into the mud.

Most of the items are incomplete and often we have only one specimen for each identified group. Thus for the Gallo-Roman period, for example, a unique fragment of upper is too incomplete to allow a precise identification of the shoe type.

Two sandals were also found. One, a child's sandal, entirely made by sewing, bears only one hole in the forefoot: this leads one to assume that the string drawn between the toes was a thin flattened strap. The other sandal – together with a further six fragments of shoes – belongs to the type with a nailed sole. It is possible from these fragments to differentiate two groups from the layout of the nails. In one group the average space between the nails is 3cm and the nail diameter is 1.1cm (there is only one example of this type; Fig. 1A). In the other

1. Roman nailed soles (Rouen).

group the average space between the nails is only 1.5cm and the nail diameter is 0.5cm (there are six items for this group).

Iconographic layouts revealed the existence of subgroups within the second group. Indeed, although they all possess a single line of nails parallel to the edge of the sole and similar dispositions for the fittings, four distinctive designs are present on the forefoot. Those are: the diamond (single item, Fig. 1B1), the triangle (single item, Fig. 1B2), the cross (two items, Fig. 1B3) and the dotted circle (two items, Fig. 1B4). Such a small sample, however, did not permit us to tie each layout to a specific period.

For the medieval period, the sole parts also dominate with thirty-five soles recorded for only five uppers. Close examination of the shape of the sole parts allows four divisions to be made:

- a type where the fitting is ended by a pointed piece projecting into the upper. This is a single item dating from the twelfth or the thirteenth century (Fig. 2A) and is, as far as we know, the southernmost piece discovered in Europe as yet;
- a type where the arch is hardly shaped (nineteen items dating from the twelfth or thirteenth century) (Fig. 2B);
- a type where the arch, neatly marked, is set almost halfway up the sole (fourteen items dating from the late twelfth to thirteenth century) (Fig. 2C);
- a type with a well marked fitting but situated more harmoniously with the anatomy of the foot and dating back to the end of the fourteenth century (Fig. 2D).

2. Shapes of medieval soles (Rouen).

Alongside this close examination of the shapes, the techniques of sole-making were examined. All were made by the turn-shoe method; they have been classified according to either the kind of punching of the sole or the presence of a rand. Three groups were obtained in this way:

- a group with the sole punched all the way through with the sewing 5mm from the edge (two items dated from the twelfth or thirteenth century);
- a group where the sewing goes through one side of the sole, comes through the edge and goes right through the upper;
- a group where the sewing goes through one side of the sole, comes through the edge and goes right through the rand before going through the upper (seven items).

The clear-cut distinction between the last two types of fittings can only be made when fragments of rand or upper have survived. Thus for the twenty-four individual soles from the site at Rouen, classification remained uncertain.

Five uppers that allow a typological identification all correspond to a distinct class. Item 2338/2 (Fig. 3A), dated to the late twelfth century or early thirteenth century, is what we now call a court shoe. As only a fragment survived, it is impossible to determine whether the upper was made of a single piece or fitted with a vamp and a quarter. Similar models have been discovered at London and York from the tenth century, and from the twelfth century to thirteenth century contexts respectively.

The next three items all belong to archaeological contexts dating from the thirteenth century. First there is an ankle boot (Fig. 3B) made of a main piece fitted in the seat. The boot was fastened to the foot by means of a lace tied around the ankle. Parallels to this group, from eleventh and twelfth century contexts, are known in Oslo and Schleswig.

The next group corresponds to an ankle boot with no closing system, made of a main piece wrapping the foot (Fig. 3C). A close example was published from Groningen (twelfth century to thirteenth century) and a similar boot was excavated at Tourcoing within a twelfth-century context.

We then have a fragment that formed part of an ankle boot made of a single piece wrapping the foot. A lace around the ankle maintained the boot in place (Fig. 3D). The incomplete state of the item prevented comparative study.

The last item from Rouen is an ornamented fragment of 20 × 14.5cm, evidently not from a shoe, dating from the fifteenth century. A honeycomb motif is composed of four superimposed friezes. Two of them form

3. Medieval shoe types (Rouen).

a scroll pattern inhabited by animals, real or imaginary, the third register is purely floral while the fourth is illegible. On one side some stitches remain, suggesting that this fragment may have belonged to a box or case.

The finds from Saint-Denis

Excavations in Saint-Denis on the northern outskirts of Paris started in 1973. Features such as pits, ditches or riverbanks scattered across the centre of town yielded hundreds of leather items, study of which is still in progress. No leather was found in the tombs of the necropolis bordering the basilica.

Leather items found at Saint-Denis span the Roman period through to the fifteenth century. The bulk of this collection is made up of shoes, although scabbards, belts, purses and so on have also been found. The distribution of finds is chronologically uneven but most of the finds are Carolingian (eighth century to tenth century) to late medieval.

Items of early medieval date were found in clay ditches bordering ramparts ordered in 869 by Charles the Bald. Besides a ball and some scabbards, the collection is composed of fragments of shoes, thirty-eight of which were complete enough to be typologically identified. The condition of the leather is poor and nearly all the fragile soles are split.

Two types of construction were identified. One involves stitching that goes through the inner part of the sole before puncturing the upper. In the other the stitching starts from the inner part of the sole, comes out on the edge and only then punctures the upper.

The collection can be divided into three groups by classifying the uppers:

- Twenty-two fragments are of court shoes, closed by a lace tied around the ankle, or by a bond that is attached to the forefoot, or with no shutting system at all. Some, with decorative sewing on the forepart of the vamp, are similar to types found at Hedeby and Middelburg.
- Ten fragments are from ankle boots closed by a tongue on the side. All these shoes have a sole tapering at the back. This type of sole, of Carolingian date, is also attested at Rouen in the thirteenth century. The form of the upper is different, however, and this model of ankle boot compares well with examples from Hedeby, York and Middelburg.
- The third group is composed of shoes made of one piece and with the main sewing following the centre line of the sole (Fig. 4). Each of the three complete pieces on the six classified corresponds to a different pattern, which has led us to divide this group into three sub-groups. Up to now we have not found similar objects from other sites, despite documentary research.

Of the few examples of shoes discovered at Rouen or at Saint-Denis, some recall other assemblages excavated on other sites, whereas others are of a new type. As yet it is too soon to classify them as variants of types well defined abroad or to create new categories.

We hope that the discovery and the study of other assemblages in France will be the means to broaden our knowledge on the technology and typology of shoemaking in Europe.

LEATHER FINDS FROM ROUEN & SAINT-DENIS

4. Carolingian shoe made almost entirely of one piece of leather, with a small section added to the side of the foot (reproduced by permission of Unité d'Archéologie de la Ville de St Denis).

5. Fifteenth-century decorated fragment (Rouen).

Acknowledgement

We thank Miss L. Garenne-Marot for the translation of this text into English.

Bibliography

Barbieux, J. (1986) 'Les fouilles de la Grand Place', *Tourcoing et le pays de ferrain* **7**, 19–29.
Braat, W. (1942) 'Nieuwe vondsten te Middelburg', *Oudheikundige Mededelingen Leiden* **23**, 15–29.
Delestre, X. (ed.) (1994) *Rouen 1992–1994 archéologie et travaux*, Rouen.
Gadagnin, R. (1988) 'L'artisanat des textiles et des cuirs', exhibition catalogue *Un village au temps de Charlemagne: Moines et paysans de l'abbaye de Saint- Denis du VII ème s. à l'an Mil*, 275–6, Paris.
Gadagnin, R. (1988) 'Le travail du cuir', exhibition catalogue *Un village au temps de Charlemagne: Moines et paysans de l'abbaye de Saint- Denis du VII éme s. à l'an Mil*, 289–90, Paris.
Grew, F. and Neergaard, M. de (1988) *Shoes and Pattens*, London.
Groenman-van Waateringe, W. (1984) *Die Lederfunde von Haithabu*, Neumünster.
Heitz, C., Meyer, O. and Wyss, M. (1988) 'L'environnement urbain du monastère de Saint-Denis à l'époque carolingienne', exhibition catalogue *Un village au temps de Charlemagne: Moines et paysans de l'abbaye de Saint-Denis du VII ème s. à l'an Mil*, 60–69, Paris.
Montembault, V. (1992) 'L'étude typologique des chaussures archéologiques', in *Autour du Cuir*, Guiry en Vexin, 115–31, 7–8 April 1991, Musée archeologique départemental du val d'oise.
Schia, E. (1979) 'Laermaterialet', in *De Arkeologiske Utgravninger i Gamlebyen Oslo*, 2, G. Faerden et al., Feltene, Oslogate 3 og 7. Be byggelsesrester og funngrupper, Bergen, 47–58.
Schnack, C. (1992) *Die Mittelalterlichen Schuhe aus Schleswig*, Neumünster.
Wyss, M. (ed.) (1996) *Atlas Historique de Saint-Denis*, DAF, 59, Paris.

◆6◆

Trading in Fur, from Classical Antiquity to the Early Middle Ages

James Howard-Johnston [1]

On an evening in June 860, a Viking fleet sailed down the Bosphorus past the greatest Christian city of the early medieval Mediterranean. Soon the city was under attack. The atmosphere of the time was caught by one highly placed eyewitness, the Patriarch Photius. In a sermon delivered soon after the lifting of the siege, he recalled the first impression the northerners had made on the citizens of Constantinople.

> Do you recollect that murky and terrible night when the orb of all our lives was setting with the orb of the sun, and the light of our life was sinking into the deep darkness of death? Do you recollect that unbearable and bitter hour when the barbarians' boats came sailing down at you, wafting a breath of cruelty, savagery and murder? When the sea spread out its serene and unruffled surface, granting them gentle and agreeable sailing, while, waxing wild, it stirred up against us the waves of war? When the boats went past the city showing their crews with swords raised, as if theatening the city with death by the sword? When all human hope ebbed away from men, and the city was moored only with recourse to the divine? When quaking and darkness held our minds, and our ears would hear nothing but, "The barbarians have penetrated within the walls, and the city has been taken by the enemy"? (Mango 1958: 100–101).

Before long similar long-distance raiding probes were affecting the Caspian provinces of the Caliphate. Three early attacks are recorded: between 864 and 884, in 909, and, in great force, in 910 (Minorsky 1958: 111–12).

When we remember the huge distances the Vikings had travelled to reach these southern seas and the many hazards they had encountered *en route*, we must view these ventures as the most spectacular examples of a competitive, heroic ethos in action in late antiquity and the Middle Ages. But so rapid was the advance of the Vikings into an alien world, so extensive the zones of deep forest and wooded steppe over which they exercised authority within a century or so of their initial penetration into Russia, that an additional explanation must be sought besides the traditional Germanic striving for glory and wealth. Were there peculiar features in the lightly settled eastern Slav lands that made them particularly attractive and peculiarly vulnerable to northern predators? Were there developments afoot within the vast continental hinterland to the southeast of the Baltic that might explain the scale of Viking expansion?

Material evidence in the form of coins provides an unequivocal answer. Silver dirhams, most minted at the eastern extremity of the Caliphate, flowed into Russia and the Baltic in huge quantities in the course of the ninth and tenth centuries. Some 70,000 dirhams have been collected from Viking-age hoards in Sweden alone. If the finds from other Scandinavian countries, Poland and Russia are added in, a grand total of the order of 200,000 dirhams recovered and recorded can be obtained. But this figure, it must be remembered, represents only the reported fraction of the recovered fraction of the unretrieved fraction of the originally concealed fraction of the capital of the original owners. It follows therefore that there were *millions* of dirhams in Russia, Poland and Scandinavia in the ninth and tenth centuries.[2]

The flow northward of coined precious metal on this scale is inexplicable save in a commercial context. It presupposes that goods were being exchanged on a large scale between the Caliphate and the north in the ninth and tenth centuries. The phenomenon, however, is more than a supposition, based on inferences from the material evidence. For it is well attested in the writings of contemporary Arab travellers and geographers. The special value of the numismatic evidence is that it enables us to appreciate the scale of the phenomenon and to give it reasonably precise chronological definition. It can therefore be stated with confidence that commercial connections on a considerable scale were established between north and south by the beginning of the ninth century and that the number of transactions and volume of commodities exchanged soon achieved a high level; one that was sustained in general until the last quarter of the tenth century.

The beginnings can be traced back to the middle of the eighth century or soon thereafter. Numerous deposits of single coins, late Sasanian

drachms as well as Umayyad dirhams from Iraq, suggest that coins were trickling from south to north by or soon after the Abbasid revolution (747–50), drawing much of its military strength from eastern Iran, shifted the political centre of gravity of the Caliphate eastward from Syria to Iraq and Iran.[3] The rate of flow increased significantly at the end of the eighth century, when the first of many substantial hoards of Abbasid dirhams was concealed in the far north (at Staraja Ladoga, within easy reach of the Baltic). It is clear then, that the initial development of trading contacts antedated the Viking drive to the southeast, dateable *inter alia* by the temporary disruption, registered in the numismatic record, to commercial exchange that it caused from the 820s to the 840s.[4] In this huge continental arena, as in the northern seas, the Vikings were demonstrably predators, lured by the prospect of material gain on a large scale in a growing market aligned along the waterways of Russia.

The Caliphate had a wide range of manufactured goods to offer the north, as well as exotic natural products from within and beyond its own territory. What could the north offer in exchange? What northern product or products could be sold at prices high enough and in volumes large enough, to match or more than to match the cost of goods bought in the south? How was the north able to generate so impressive a profit in its dealings with the south, if, as seems probable, the dirhams represent a surplus accruing to the north? There is no question of traditional northern exports to the south – amber, honey, wax – fuelling commercial exchange on this scale. Nor, indeed, is it likely that weaponry and slaves, which featured in Arab lists of northern exports in the ninth and tenth centuries, could do so, let alone generate so substantial a balance of payments surplus.

One quintessentially northern product remains to be considered – fur in all its varieties, from the relatively humdrum pelts of tree-martens, foxes and squirrels of the wooded steppe and mixed forest zones of western Eurasia to the highly prized products of the eldorado of furs to the north and east of Novgorod: ermine, from the northern stoat which turns white in winter; sable, from the marten of the region with a dark brown or black pelt; and minever, the white fur, edged with grey, of the belly of the northern squirrel (Veale 1966: 22–4). These were evidently traded with the Caliphate on a large scale in the period that concerns us. We are left in no doubt of this by an impressive array of testimonies in Arab texts, chiefly the geographical works written to satisfy the curiosity of thriving urban mercantile elites, the best of them dating from the tenth century. The principal intermediaries in the commerce of the north with the Caliphate were the Bulgars of the middle Volga, who

dealt mainly with Khwarezm, the once fertile region south of the Aral Sea, which seems to have been the main processing and distribution centre for furs in the Caliphate.[5] Muqaddasi, one of the stars of Arab geography in the tenth century, gives the following list of goods supplied by the Volga-Bulgars to Khwarezm:

> sables, minever, ermines, and the fur of steppe foxes, martens, foxes, beavers, spotted hares and goats; also wax, arrows, birch bark, high fur caps, fish glue, fish teeth, castoreum, amber, prepared horse hides, honey, hazel nuts, falcons, swords, armour, khalanj wood, Slavonic slaves, sheep, and cattle. (Barthold 1968: 235)

The dominant role of fur on the main southern leg of the north–south trade route is indicated by its position and prominence in this list.

We now come face-to-face with an important historical question. Were the relations between north and south transformed in the course of the eighth and ninth centuries? Was this the period when fur first entered southern markets as a key commodity? Or are we, as so often, the prisoners of evidence that happens to have survived? Should we resist reading too much into the reports of Arab geographers, viewing them rather as manifestations of cultural change in the south, as evidence of a new curiosity that led them to record, for the first time, age-old economic phenomena? Was cultural change in the north, a new appetite for bullion or possibly a growing demand for a convenient medium of exchange, responsible for the inflow of silver? Or, finally, was there significant but not transforming economic change, the volume of commercial transactions growing substantially from a long-established lower level, and was there an accompanying shift in the terms of trade in favour of the north?

An answer may be obtained if we cast an eye over the millennium extending from 500BC to AD500 and search classical sources for references to the importation or wearing of fur, and if we then compare the results with those obtainable from within the following millennium. If fur can be shown to have been an important element in north–south exchange in classical antiquity, then the change was primarily cultural and we should dismiss as an optical illusion the picture suggested by textual and numismatic evidence of a massive irruption of fur into southern markets in the early Middle Ages.

Fur may be classified as a commodity. Its insulating properties enable it to protect the body, awake or asleep, against the cold. In the Middle Ages, when evidence is most easily obtainable, fur was used for inner and outer clothing, sometimes comprising several layers. The outer garment might have its fur facing outward but usually, at least in elite groups, was used as lining with only the edging showing. Fur was also used for caps, the interior of shoes, bed-coverings and the lining of tents. Other materials could, of course, perform the same function. They ranged from relatively unprocessed sheepskins to the finest woollen, linen and silk textiles. Fur was not a necessity, since there were readily obtainable substitutes. Its attraction lay in its superior efficiency as an insulator and, in the case of the pelts of the far north, their aesthetically pleasing colours.

There was therefore a large potential market for fur in all regions where winter makes its mark. There was what might be termed the intermediate north – transalpine Europe, the wooded and open steppes of western Eurasia – with its severe and prolonged winters; there were regions with a relatively harsh climate by virtue of their elevation – the mountains of Italy and the Balkans, the plateaux of Castile, Anatolia and Iran with their fringing mountains.; and the inhabitants of warmer climes, like the Mediterranean coastlands or Arabia and the arc of the Fertile Crescent to its north, would appreciate fur during their shorter, but sometimes bitter winters. Of these regions we are primarily concerned with the second and third, highlands and lowlands in the Mediterranean and its eastern hinterland. For their cultural, social and economic development was far more advanced than that of the intermediate north in classical antiquity (with the partial exception of Gaul and adjoining territories, after their incorporation into the Roman Empire). With often highly concentrated settlements and effective centralised state structures they generated massive demand for goods and produce both from within and beyond the territories controlled by individual political authorities, a demand that could, and did, exercise considerable influence on the north. This being so, it is not unreasonable to suppose, as (to cite one example among many) Cunliffe (1988: 9, 177–82) does, that the societies of the Mediterranean world appreciated the qualities of fur, that trading connections were established with the north (there being no shortage of entrepreneurs in the south) and that there was a steady movement southward of furs in considerable quantities in prehistoric and classical times.

There is, however, very little evidence that furs were being worn, and hence that there was any significant demand in the Mediterranean world,

in the Greek, Hellenistic and Roman periods.[6] There is none at all for fur-wearing by elite groups in core territories. This is likely to have been equally true of the pre-literate period. Reasons are not too hard to find. The fur-bearing forests lay outside the activated hinterland of the Mediterranean in prehistoric times and during the first, Greek, half-millenium of classical antiquity, a period when cultural patterns were formed and were set in the south. These patterns continued to exert influence in the second, Roman half-millennium, during which the eldorado of furs in the far north remained in the remote hinterland of the empire's hinterland, but the main fur-yielding lands came within the economic field of gravity of the south. Distance and the difficulties and hazards of long journeys inhibited the growth of north–south commerce in general and trading in fur in particular.

But goods were exchanged between north and south in classical antiquity. So there was no insurmountable obstacle barring furs from southern markets. The crucial role was played by a barrier of quite a different sort; that erected in southern minds. It was the immaterial, ideological frontier between the civilised *oikoumene* and a barbarian outer world. The outer world was represented as alien and menacing, as the antithesis of the civilised. One of the many oppositions embedded within the antithesis was that between wearers of processed clothing (textiles of all sorts) and wearers of relatively unprocessed clothing (skins). The distinction is noted in many texts, the most valuable testimony coming from authors who were directly acquainted with northern peoples, foremost among them Caesar, Ovid and Tacitus. They note that northerners wore 'skins', a custom that they view with some distaste, Ovid expressing himself more forcefully than the others. Fur-wearing is reported in a matter-of-fact way, its importance as a demarcator of the barbarian being asserted implicitly by the writer's tone rather than being expressed openly.[7]

It may be objected that the latter-day historian, living in an anthropologically orientated age, should not read so much into such remarks, which are a very minor element in southern portrayals of the northern barbarian. Too much, however, should not be made of the incidental character of observations about barbarian dress. For this was not the main concern of the intellectual and political circles that articulated and developed the idea of the barbarian. They were much more interested in differences between mental dispositions, belief systems, moral codes and their behavioural manifestations (at the level of individuals and social groups) than in physical differences, whether of physiognomy or diet, housing or clothing. As a consequence of this concentration on crucial

divergences of temperament and ethics, there was no systematic discussion of observed and reported differences in material conditions and ways of life, including differences of dress, and what was observed prompted no systematic reflection.[8]

There can, however, be little doubt that southerners disregarded or disdained the wearing of furs, more or less unthinkingly. This explains why it never crossed Pliny the Elder's mind that fur from the weasel family, to which the marten belongs, might have a use in clothing. He is entirely preoccupied with the medicinal properties of various parts of its body (Jones 1963). Such an attitude also explains why neither Greek nor Latin makes a distinction between hides and leather on the one hand and pelts and fur on the other. They are bracketed together as *skins*, *dermata* and *pelles*. The long, densely packed hairs shielding the skins of small mammals from harsh northern winters are not noticed and therefore evidently not appreciated by these southern tongues.

Fur was not accepted as a commodity in the Greco–Roman world. It is a clear case of culturally diminished value. The intrinsic worth of a substance was artificially reduced to nothing or close to nothing by a set of widely held beliefs. These originated in a scheme of thought devised, developed and propagated by the literate elite. This percolated down the social order and out into the peripheries from the governing centres. A large potential market thus failed to generate the demand that might have been expected.[9] This is not to say that furs were never worn in Mediterranean lands in the classical period, but that those who did so were far removed from the elite and marginal to the main body of society. Only two groups spring to mind. First the deviant youth sub-cultures, which the most civilised and best ordered of states may spawn, eager to shock and determined to mark themselves off from conventional society. One possible case is that of the fans of different racing colours in the circus in the sixth century AD with their penchant for outlandish haircuts and clothes, including Hunnic cloaks, trousers and shoes (Dewing 1935: 80–81). Second Germanic emigrés, both soldiers who served in large numbers in Roman or federate units and whole peoples who settled on Roman territory. Although the evidence suggests that they rapidly adopted Roman ways, including Roman ways of dressing, there was an initial phase in which they maintained old habits.[10] There was therefore some actual demand for furs in the heart of the southern world towards the end of classical antiquity, which seems to have stimulated some long-distance trading on a limited scale. For the first time there is evidence of contact, indirect, through numerous intermediaries, perhaps ephemeral, with the remote eldorado of furs in the far north.[11]

But with these exceptions, and perhaps some pockets of aberrant dressing in remote and refractory highland districts, furs were not worn and hence not in demand in Mediterranean lands and those parts of continental Europe that were incorporated into the Roman empire and permeated by Mediterranean culture. The main market for fur, outside the natural habitat of fur-bearing creatures, was probably to be found in the steppes. Furs were needed and there is nothing in the scanty evidence to suggest that they were not appreciated and used on a large scale by nomad peoples.[12] The demand generated was, however, relatively modest, since nomad numbers were limited. An isolated reference in a late Roman lexicon may point to the existence of a second subsidiary market in Iran, perhaps largely confined to its steppe marches in the northeast (Khurasan).[13]

This hasty survey of the classical world enables us to answer the question put above. There was a real qualitative change in north–south relations in the eighth and ninth centuries, not simply one of perceptions, and it was much more than a significant but limited growth in volume of goods exchanged. The most valuable and easily transportable commodity, produced naturally on a huge scale in the north, for the first time entered southern markets in large quantities. One consequence was the development of a new, eastern axis of trade between north and south, and another the Viking thrust through Russia towards the rich lands of the south.

The principal explanation is to be sought in the south. It is not too hard to find, once one starts to look. Elite culture in the new empire created by Islam within a generation of the death of the Prophet in 632 differed from that of Greeks and Romans in its ideology. It was formed and set in the first, extraordinarily dynamic phase of Islamic history. Military and political expansion was programmed in from the start. There was no fixed, recognised boundary to the abode of Islam. The outer world was regarded with none of the fearfulness shown at certain times by Greeks and Romans. There was no recognition of neighbouring powers as autonomous, coexistent entities. There was no fixed divide between the Caliphate and the world beyond, as there had been for the Roman empire from the first century AD. The outer world was the arena of war, of continuing holy war, which might only be suspended for limited periods. The whole Muslim community was, in theory, engaged in the grand enterprise of bringing Islam to the attention of all mankind, of projecting Islam over the whole known world. The stereotype of the

barbarian fell to bits. Instead Muslims looked out at the variegated peoples of the outer world with boundless curiosity, and, in due course, their observations and impressions were recorded in writing for a large domestic audience. The immaterial barrier between interior, civilised culture and outer barbarism was destroyed.[14]

A second remarkable feature of early Islamic history was the quickening pace of economic development in the eastern, continental hinterland of the Mediterranean. A mercantile ethos long implanted in Arabia, a deliberate removal of all barriers to trade, rapid urban growth (already under way in Iran in late antiquity, but boosted by Arab colonisation), and increased specialisation and diversification of production led to rapid growth in commercial activity. This in turn promoted more urban growth, more specialisation, larger elites with greater purchasing power and more refined tastes, which in turn promoted more trade within and between regions. Several virtuous circles can be seen to be at work. The centre of economic gravity moved east, to the Iranian heartland of the new empire and its outliers in the northwest (Transcaucasia) and the northeast (Transoxiana) (Lombard 1975). This growth in economic activity naturally affected neighbouring regions beyond the (temporary) frontiers of the Caliphate. Vast commercial hinterlands were developed: to the east along the Silk Road; to the south embracing the whole Indian Ocean; and to the north and northwest reaching out over steppes, eastern Europe and Russia. The fur-bearing forests, including those of the eldorado to the north and east of Novgorod, were now brought within the field of influence of a southern economic power.

The barriers, cultural and physical, that had hitherto kept fur out of southern markets in any quantity, had been removed. But inertia, unthinking adherence to traditional customs, might still have inhibited the growth of demand, but for a third development. This was a radical change in attitudes among the elites of the new empire. Much research remains to be done, but such evidence as is known to me suggests that the crucial change in taste and fashion occurred very soon after the Abbasid revolution of 747–50. By the reign of al-Mahdi (775–85), there was nothing unusual in a courtier appearing before the Caliph in furs, in this case a future vizir who had been hitherto out of favour (Kennedy 1990: 225). When al-Mahdi's successor, Harun al-Rashid, died in 809, there was said to have been a stock of four thousand robes lined with sable in his treasury (Gil 1974: 313, n.56). Furs soon played an important role in gift exchange between courts: for example, the hats of sable sent by Ismail, Samanid ruler of Transoxiana, to the Caliph al-Mutadid in Baghdad in 893 (Gil 1974: 312–13). By that time fur was becoming part of

the insignia of royal office, to judge by the incident in 913 when the secretary who had murdered Ismail's son and successor Ahmad wore Ismail's sable high hat as a visible sign of his assumption of power as he rode into Bukhara.[15]

Fur was transformed from the garb of the alien outsider to an accepted part of the dress of high-ranking Muslims. It is impossible to trace the process of this transformation, but it may be suspected that a crucial role was played by the northeast borderland region of Iran, Khurasan, traditionally exposed to steppe influences, where furs may have made some inroads into sedentary society in the pre-Islamic period (as suggested, tentatively, above). For it was precisely there that a significant proportion of the new Arab colonists mixed relatively freely with established local Iranian elites and were most likely to have imitated their customs (Shaban 1970). The seizure of the Caliphate by the Abbasids, which was only made possible by the political and military backing of Khurasan, opened the way for a large-scale reverse movement of population from periphery to centre, to the new Abbasid capital at Baghdad. This is the context, a movement of elites as well as troops, in which fur-wearing is most likely to have made the leap from a marginal phenomenon in a frontier region to the governing centre of the great power of early medieval western Eurasia.

Once fur-wearing entered court life in Baghdad, the south began not only to appreciate furs as commodities for the first time, thereby beginning to activate its long dormant potential demand for furs, but its perception of their value was enhanced by knowledge of their use in high places. Furs were beginning to become status symbols. The practice of wearing furs was probably imitated widely and rapidly within the Caliphate, not just in the courts of (notionally) subordinate rulers on the periphery and of governors nearer at hand, but also by the leading families of the booming cities (Ahsan 1979: 75). This explains why demand rocketed in the way suggested by both numismatic and textual evidence, in the course of the ninth century. For even relatively small numbers of wealthy individuals could generate a high demand for the pelts of small forest mammals. An extreme example of the scale of demand created by the wardrobe of a single individual can be obtained from the best documented of medieval courts, that of England: Edward III's mother, Queen Isabella, had six counterpanes lined with minever, one of which contained 1,396 pelts, while a single 'robe' of Henry IV, an outfit consisting of nine separate garments, incorporated nearly 12,000 squirrel and 80 ermine pelts (Veale 1966: 20–21). In the case of the Caliphate in the ninth and tenth centuries, however, we are not dealing with small numbers nor with a

society lacking in purchasing power or products to sell in exchange. A highly urbanised world, with superimposed, well staffed apparatuses of government, headed by the richest court of the age, was capable of absorbing huge quantities of furs and paying high prices for them, hence was capable of transforming age-old relations between north and south.

But what of the western half of the southern world, which fronted the forests of Russia, eastern Europe and Scandinavia? Did this second, large potential market remain dormant in the early Middle Ages, or did it too drop the old aversion for furs? Did the example of Islamic courts, above all that of the Caliphs at Baghdad, inspire those of Byzantium and the West to follow suit? In the case of Byzantium, the answer is unsurprising. The most Roman of the sub-Roman successor states of the old empire was the most reluctant to drop the old standards. Undoubtedly furs were beginning to be worn by a few in the period when they swept over the Caliphate, and the practice became somewhat more widespread from the end of the eleventh century. But the Gadarene rush to flaunt expensive furs, which shocked some churchmen in the West has no counterpart in Byzantium.[16]

The ideological barrier inherited from classical antiquity, and willingly embraced by migrant Germanic peoples as their rulers and courts aped Roman ceremonial and manners, was eventually eroded away in the West. Collapse came in the second half of the eleventh century, when Adam of Bremen and Peter Damian were provoked into denouncing the new rage for luxury furs. It is harder to observe the gradual weakening of Germanic attachment to *romanitas* in dress in the preceding centuries, but it looks as if the key phase coincided paradoxically with the last flourish of *romanitas* at the political level. For it is from the Carolingian age that evidence can first be obtained of furs being worn and of furriers as an established trade (Delort 1978: 320–22).

The vogue for furs in the Caliphate probably exercised some influence over these developments in the West. It may be that furs were now prized not only as luxuries, as manifestations of wealth and status, but also as visible marks of a superior, refined civilisation (Delort 1978: 322–5). If so, the wheel would have turned full circle. However, there were yet more important consequences in the north, in Russia. The rapidly growing demand for furs in the south was met by hunting and trapping in the forests of the north. It was a curious conjunction of intensive demand and extraordinarily extensive supply. Each southern household's appetite for hundreds, if not thousands of pelts, could only be satisfied by bringing a large tract of northern forest into the south's economic hinterland. The process had started before the Vikings intervened but

clearly accelerated rapidly thereafter, the Vikings acting as intermediaries between those involved in the extraction and initial processing of the forests' resources, in the main Slavs, and the organised entrepots of the intermediate north (in Volga-Bulgar and Khazar territory). The economic demand of the south impelled the Vikings to spread themselves thinly over the Russian lands, moving along the waterways to tap the resources of remote recesses of the forest. It also left them no choice but to deal gently with the Slav tribes with whom they were trading. There was no question of their imposing a harsh autocratic regime over peoples who far outnumbered them and were scattered over huge areas. Those two most striking phenomena of early Russian history, the rapid creation of a set of interrelated states covering the whole of Russia west of the Urals in the ninth century and the evident symbiosis of Viking and Slav, which resulted, within two centuries, in the crystallisation of a mixed culture in the towns, can best be explained, I believe, if they are placed in the context of the fur trade and its ramifications in the north (Franklin and Shepard 1996).

Two other, remoter consequences should perhaps be noted before we halt this hasty exploration of a large topic. I owe the first to the observation, made by the late Michael Dols, that the bubonic plague-carrying flea can survive for between four and six months in furs. The toll of the Black Death, far higher than its sixth century counterpart, may be partly explicable by the widespread wearing of furs in the Near East, the Mediterranean and continental Europe. The second, familiar consequence is the Russian colonisation of Siberia from the end of the sixteenth century, which was partly driven by the search for new fur-bearing forests to replace those largely stripped of their resources west of the Urals (Schier 1951: 55–9; Parker 1968).

Notes

1. This paper is an interim report on work in progress. I hope to publish before long a more definitive version with fuller annotation. Much that is said here will require amplification, some of it (I hope not too much) modification. I have gained a great deal from discussion with my colleagues at Corpus and from the contributions of those who heard an early version at the Oxford Byzantine Studies Seminar in 1988.
2. Overviews can be found in Sawyer (1982: ch.8), with an idiosyncratic view of the historical context, and Spufford (1988: 64–73). Detailed analyses of Russian finds can be found in Janina (1956: 79–140) and Noonan (1981: 47–117).
3. Welin (1974: 22–8) presents the evidence (31 coins with 30 distinct provenances),

concluding, rather boldly (and unconvincingly), that trading connections were established in the early eighth century.
4. Noonan (1981: 74–8) prefers to explain the decline in the northward flow of dirhams by a diminution in mint output in the Caliphate (1981: 75).
5. Lombard (1969). Martin (1986: chs 1&2) assembles a full set of references from Arab texts. Some archaeological evidence for the hunting of fur-bearing animals has been found within the territory of the Volga-Bulgars – a number of blunted arrowheads of iron or bone, specially designed to avoid damaging the pelt (Martin 1986: 6–7).
6. Like all arguments from silence, this one must be advanced with caution. But it is surely more foolhardy to disregard the cumulative negative evidence provided by the whole body of classical writing as is done in the older literature on the fur trade; for example, Fougerat (1914) and Hennig (1930: 1–25). Hennig goes so far as to suppose that furs from Siberia were reaching the fringes of the Mediterranean world by the seventh century BC. Like his predecessors, Schier (1951: 7–20) assumes that fur was traded wherever amber can be traced in transit; he then pieces together a picture of active north–south trading in western Europe involving four main arteries, and suggests, in a bold stroke of his own, that an eastern artery passing through the region around the confluence of the Volga and Kama rivers, where the Bulgars would later establish their power, was already in existence in the fifth century BC.
7. Caesar – Edwards (1952: 180–83, 252–3); Ovid – Wheeler (1988: 136–41, 234–9, 244–9); Tacitus – Hutton (1970: 156–7).
8. The northerner had little effect on the Greek stereotype of the barbarian, which can be observed in the process of formation in the works of Athenian dramatists in the fifth century BC (Hall 1989). For Greek eyes were turned east, focused, with the help of self-interested Athenian propaganda, on the powerful, alien, threatening presence of the Persian Empire. In so far as notice was taken of the barbarian's garb, the fine robes of the easterner, an outward manifestation of a soft and self-indulgent temperament, caught the eye, rather than the furs worn by the northerner. Half a millenium later, however, the northern barbarian had replaced the eastern as the principal perceived threat to the Mediterranean world and the stereotype of the outsider was reshaped accordingly. Roman writers followed the Greek example of paying little attention to the material accoutrements of the barbarian, concentrating instead on different aspects of the wildness (*feritas*) and fierceness (*ferocia*) which were picked out as his principal defining characteristics (Dauge 1981). An outer clothing of animal pelts fitted neatly into this *schema*. This was made explicit in the sixth century by Procopius *à propos* of the semi-legendary Scritiphini, a tribe of the far north (Dewing 1919: 418–21).
9. This should come as no surprise to late twentieth-century readers, who have witnessed the extrusion of furs from southern lands as attitudes to the exploitation of the animal world have changed with startling speed.
10. Delort (1978: 319–20). Delort also notes that there is evidence of limited demand for beaver pelts at certain times within the Roman Empire (a state-controlled valuation, which is low, features in the *Price Edict* of Diocletian, for example). But we do not know to what use they were put nor by whom nor where.
11. In the geographical introduction to the *Getica* (Mierow 1915), Jordanes refers twice to trading in furs: at c.3 (p.56), he mentions an unnamed people in Scandinavia, 'who send through innumerable other tribes the sapphire colored skins to trade for Roman use. They are a people famed for the dark beauty of their furs and, though living in

12. poverty, are most richly clothed'; in c.5 (p.60) he notes that one of the peoples of the Ukrainian steppe, the Hunuguri, 'are known to us from the fact that they trade in marten skins'.
12. For example, Priscus, frag. 15.4 (Blockley 1983: 298–9). Hun princes adorned themselves with 'skins of wild animals'.
13. Hesychius of Alexandria (Schmidt 1862: 31) defines *simor* (evidently related to Arabic *sammur*, 'sable') as a Parthian word for 'a type of wild mouse, the skins of which they use for clothing'. Hesychius probably lived in the sixth rather than the fifth century AD (Latte 1953: vii–viii). The antiquarian use of Parthian for the contemporary Sasanian Persians is to be expected in a grammarian.
14. Goitein (1966: 3–53); Khadduri (1955); Miquel (1967). It should be noted, however, that the primary concern of geographers, in the mid tenth century heyday of the genre, was to write 'total geography' of the Islamic lands. This led to a temporary neglect but not exclusion of the outer world, which had loomed much larger in the works of their predecessors and would do so again in the high Middle Ages.
15. A reference which I owe to my colleague, Luke Treadwell – from the unpublished *Tarikh al-duwal al-Islamiyya* of Ibn Zafir. The relevant section is preserved in Codex arab. G6 of the Ambrosiana Library in Milan. It is identified and discussed by Madelung (1973).
16. The role of furs in Byzantium will be investigated in another paper.

References

Ahsan, M. M. (1979) *Social Life under the Abbasids*, London & New York.
Barthold, W. B. (1968) *Turkestan down to the Mongol invasion*, London.
Blockley, R. C. (ed. and trans.) (1983) *The Fragmentary Classicising Historians of the Later Roman Empire*, ii, Liverpool.
Cunliffe, B. (1988) *Greeks, Romans and Barbarians: Spheres of Interaction*, London.
Dauge, Y. A. (1981) *Le Barbare: Recherches sur la conception romaine de la barbarie et de la civilisation*, Brussels.
Delort, R. (1978) *Le commerce des fourrures en occident à la fin du moyen age* 1, Bibliothèque des écoles françaises d'Athènes et de Rome 236, Rome.
Dewing, H. B. (ed. and trans.) (1919) Procopius, vol. 3; *History of the Wars*, vi.15. 16–23, Cambridge.
Dewing, H. B. (ed. and trans.) (1935) Procopius; *Secret History*, vii.14, 6, London & Cambridge, Mass.
Edwards, H. J. (ed. and trans.) (1952) Caesar; *Gallic War*, iv.1, v.14, London & Cambridge, Mass.
Fougerat, L. (1914) *La pelleterie et le vêtement de fourrure dans l'antiquité*, Paris.
Franklin, S. and Shepard, J. (1996) *The Emergence of Rus 750–1200*, London & New York.
Gil, M. (1974) 'The Radhanite merchants and the land of Radhan', *Journal of the Economic and Social History of the Orient* **17**.
Goitein, S. D. (1966) 'The four faces of Islam', *Studies in Islamic History and Institutions*, Leiden.
Hall, E. (1989) *Inventing the Barbarian: Greek Self-definition through Tragedy*, Oxford.

Hennig, R. (1930) 'Der nordeuropäische Pelzhandel in den älteren Perioden der Geschichte', *Vierteljahrschrift für Sozial- und Wirtschaftsgeschichte* **xxiii**, 1–25.

Hutton, M. (ed. and trans.) (1970) Tacitus; *Germania*, xvii, E. H. Warmington (rev.), London & Cambridge, Mass.

Janina, V. L. (1956) *Denezhno-vesovye Systemy Russkovo Srednevekovja: Domongolski Period*, Moscow.

Jones, W. H. S. (ed. and trans.) (1963) Pliny; *Natural History*, vol. 8; xxix 60, 118, 131; xxx 34, 36, 37, 47, 90, London & Cambridge, Mass.: 222–3, 258–9, 266–7, 300–303, 308–9, 334–7.

Kennedy, H. (trans.) (1990) *The History of al-Tabari: An Annotated Translation*, vol. xxix 'Al-Mansur and al-Mahdi', Albany, NY.

Khadduri, M. (1955) *War and Peace in the Law of Islam*, Baltimore.

Latte, K. (1953) *Hesychii Alexandrini Lexicon*, vol. i, Copenhagen.

Lombard, M. (1969) 'La chasse et les produits de la chasse dans le monde musulman VIIIe–XIe siècles', *Annales*, **xxiv**, 572–93 (reprinted in 1972 in his *Espaces et réseaux du haut moyen âge*, Paris, 177–204).

Lombard, M. (1975) *The Golden Age of Islam*, Amsterdam.

Madelung, W. (1973) 'The identity of two Yemenite historical manuscripts', *Journal of Near Eastern Studies* **xxxii**, 175–9.

Mango, C. (1958) *The Homilies of Photius Patriarch of Constantinople*, Cambridge, Mass.

Martin, J. (1986) *Treasure of the Land of Darkness: The Fur Trade and its Significance for Medieval Russia*, Cambridge.

Mierow, C. C. (1915) *The Gothic History of Jordanes*, Princeton.

Minorsky, V. (1958) *A History of Sharvan and Darband in the 10th–11th Centuries*, Cambridge.

Miquel, A. (1967) *La géographie humaine du monde musulman jusqu'au milieu du 11e siècle*, Paris & The Hague.

Noonan, T. S. (1981) 'Ninth-century dirham hoards from European Russia: a preliminary analysis' in *Viking-age Coinage in Northern Lands*, M. A. S. Blackburn and D. M. Metcalf (eds), Oxford: vol. i, pp.47–117.

Parker, W. H. (1968) *An Historical Geography of Russia*, London: 23, 88–9, 110–11, 123–4, 158.

Sawyer, P. H. (1982) *Kings and Vikings: Scandinavia and Europe AD700–1100*, London.

Shaban, M. A. (1970) *The Abbasid Revolution*, Cambridge: 46–8, 95–9, 155–8.

Schier, B. (1951) *Wege und Formen des ältesten Pelzhandels in Europa*, Frankfurt.

Schmidt, M. (ed.) (1862) *Hesychii Alexandrini Lexicon*, iv, Jena.

Spufford, P. (1988) *Money and its Use in Medieval Europe*, Cambridge.

Veale, E. M. (1966) *The English Fur Trade in the Later Middle Ages*, Oxford.

Welin, U. S. L. (1974) 'The first arrival of oriental coins in Scandinavia and the inception of the Viking Age in Sweden', *Fornvännen* **lxix**, 22–8.

Wheeler, A. L. (ed. and trans.) (1988) Ovid; *Tristia*, iii.10, v.7, v.10, G. P. Goold (rev.), Cambridge, Mass. & London.

◆7◆

Animal Bones from the Viking Town of Birka, Sweden

Bengt Wigh

The largest archaeological investigations thus far at Birka, the first urban centre in Sweden, began in the spring of 1990. An archaeozoologist was employed on site to organise and begin analysis of nearly 6 tonnes of animal bones. This osteological material has proved to be unique, both qualitatively and quantitatively, to the Swedish Viking period. The analysis of the material (which has just begun) will give us both new and extended knowledge of Viking period domestic animals and wild animal hunting in central Sweden. This paper will present some of the new results achieved through this latest excavation.

Birka was situated on a small island, Björkö, in Lake Mälaren, about 30 km west of modern Stockholm. At some time in the middle of the eighth century AD the ruler of central Sweden decided to found a town, based on trade and manufacturing, on Björkö. The layout of the town is similar to other early Viking towns of northern Europe with straight house plots along the lake side (Clarke and Ambrosiani 1993). The first houses of wood and clay, some with stone foundations, were built between regular stone jetties.

It has been estimated that approximately 700 to 1,000 people lived and worked in Birka. The area occupied by the town at its largest was 7 hectares. After some hundred years of existence, in the tenth century, the area around Lake Mälaren became more insecure, so a rampart was build around the town. The rampart is still partly visible on Björkö. A large hill fort was also constructed on a rocky eminence next to the town.

Cemeteries were sited outside the rampart and in the Viking period the most common burial custom was cremation with a small burial mound. But at Birka there is evidence of numerous other forms of burial

1. The location of Birka in Sweden.

rite including chamber graves with inhumations. This type of burial may indicate foreign influences or religions. More than 3,000 burial mounds still remain on Björkö (Ambrosiani 1991).

Around 975, after 200 years, the town of Birka was deserted in favour of a new town, Sigtuna, situated nearby. It is not known exactly why this change of town location took place but it could be due to a change of religion (Sigtuna was established by the first Christian king of Sweden), trade routes or a change in power structures. After abandonment the town area of Birka became farm land. The former town area came to be referred to as the Black Earth, its characteristically dark soil blackened by charcoal fragmented by ploughing. The land was used until the island was bought by the Swedish Board of National Antiquities in the 1920s when the island became a national heritage site.

As early as the 1870s the first proper archaeological excavation began in Birka. During almost twenty years, Hjalmar Stolpe, a former zoologist, excavated 4,000 m² of the town area and 1,100 graves on Björkö. Through the occurence of certain types of artefacts, it became clear that the Vikings in Birka had very well organized trading links, both long distance and local, with for instance the Byzantine empire, the Caliphate, the Rhineland, Russia and of course with all coastal towns around the Baltic sea (Clarke and Ambrosiani 1993). The excavations also proved that the local craftsmen in Birka were able to produce very high quality products like bronze ornaments, combs and tools (Ambrosiani 1991). Apart from artefacts, in the town area of Birka Stolpe also found masses of bone, mostly from food remains, but also numerous bones from fur-bearing animals (Stolpe 1872, 1873). But Stolpe had no time to make a full analysis of the bone collection, which was stored for the future (Wigh 1993).

Between 1969 and 1971 a small excavation run by Ambrosiani took place in the Black Earth of Birka. During that excavation they found stone settings of a tenth-century jetty, artefacts and thousands of bones (Ambrosiani *et al.* 1973). Some analysis of that bone material was undertaken by three archaeozoologists (Ericson, Iregren and Vretemark 1988). As with the nineteenth-century material they also found some bones of different Swedish fur-bearing animals, although no further interpretations of these bones were offered.

The archaeological excavation that began in 1990 has been carried out on what has been shown to be the earliest waterfront during the decades of the 740s and 750s. The excavated area is only 350m² but covers at least one whole house plot. The stratigraphy of the site is very complicated. From this rather small area more than 4,000 different layers have been distinguished. The excavation method used makes it possible to study each layer very carefully and all finds, together with the bones, are registered and ordered according to layer directly into a computer. The site is very well drained, which makes the soil so dry that almost no organic remains are preserved, other than bones, antler and charcoal. The bones may have been preserved because there are so many of them that they have rendered the soil more basic.

In the region where Birka was situated the isostatic land rise, compared with the normal sea level, has been almost 1m every 200 years. With changing sea level the town was able to expand with the newly gained land. The excavated area that in the year 750 formed the lake side became, with time, more and more distant from the water. Due to the rise of land, Lake Mälaren is now 6m lower in relation to the original ground level.

In the earliest phases within the excavated area a bronze casting workshop has been found. The workshop existed for only a few decades but was replaced instantly by a similar workshop on the very same plot. This rebuilding of workshops continued until the beginning of the ninth century, when the plot became an ordinary household plot, with more domestic production (textiles, *etc.*). Typical finds from the workshop are broken casting moulds, crucibles, pieces of metal, weights and failed castings. From household layers we have found, amongst other things, loom-weights and bone needles.

In the same area or next to the bronze casting workshop were also found different types of pottery, mostly locally produced, but also numbers of imported vessels. Places of origin for these imports are Finland, the western and eastern Slavonic regions (Germany, Poland and present-day Russia) and from western Europe (the Rhineland). The most long distant ceramic find is a Khazar vessel. Other typical finds are glass, amber or cornelian beads, combs made of elk antler (local) or bone (imported) and iron tools. Other finds that have travelled a long way before reaching Birka are cowrie shells from the Indian ocean and an 'ironing board' made of whalebone from northern Norway.

As with the earlier excavations, enormous amounts of bone were also found during this campaign. All bones from layers that are possible to stratify are collected in a 3mm water sieve. This 'fine' collection of bones give us evidence for the first time of the very smallest mammals, birds and fish (Wigh 1995: 88f.).

Trade with furs and skin, earlier research

Historical and archaeological records

It is known from historical records that trade in furs was important in early Scandinavian history. The first historian to mention the fur trade in Scandinavia is Jordanes, from the sixth century, who writes of the trade between Romans and the Laplanders via the Sveons. Later sources include Adam of Bremen (eleventh century), who decribes the wealth of furs and skins possessed by the Scandinavians, and Arabic reports of a fur-trade from Scandinavia through Russia to the East (Steckzén 1964: 132ff.) which is the subject of the preceeding chapter in this volume.

Artefacts

There are considerable numbers of archaeological finds that support this picture of trade and preparation of furs and skins in Sweden. Some skin-preparing tools have been found in graves from Öland, Västergötland and Östergötland. These graves are mostly dated to the second century AD (Hagberg 1967: 21). Later grave-finds of skin-working tools are rare. An explanation for the lack of special tools from the early medieval period could be that for preparing furs from smaller animals little more than a good knife and fingernails to scrape off the flesh are needed (Åkerman 1969: 55).

Biological remains

Apart from tools, there are other finds that are useful for developing an understanding of the use of furs and skin. While investigating bronze ornaments from inhumation graves from Birka, researchers have found small, mineralised pieces of fur hairs on the backs of the objects. It also has been possible to attribute the majority of these hairs to specific animal species, including pine marten, squirrel, beaver, bear and sheep. Beaver seems to be the fur most preferred, at least according to grave-finds (Geijer 1938: 157–86; Hägg 1974: 91; Hägg 1986: 53; Ågren 1993: 33).

Osteological remains

In excavations, mostly of cremation burials, archaeologists have occasionally found the third phalanges of various fur-bearing animals, such as bear, lynx and wolf. These phalanges are the surviving remains of skins on which the deceased was laid at the funeral. In these graves, dated to late Iron Age or Viking Age, are also found expensive artefacts that indicate that the owner of a skin was a wealthy person. Probably there were very few people that could afford to be buried with such a skin (Petré 1980).

There are also some urban sites where bones from fur bearing animals have been found. As mentioned before, some bones have been found at Birka in the Black Earth during previous excavations. From Sigtuna there are also some finds, mostly squirrel bones (Jonsson 1989: 56). The largest collection of fur-bearing animal bones has been found on the latest excavation at Birka, where thousands of bones have been identified.

Bones from fur and hide production on Birka

The analysis of the huge quantity of bone material has just begun, but all of it has been sorted in the field. It is already possible, therefore, to draw some preliminary conclusions concerning the Birka bones. The final report is expected to be completed in the course of 1997 as a part of the Birka Report series.

Bones from fur-bearing animals are found all over the newly excavated area in Birka. There seems to be no specific deposition of these remains, but most of them are found in passages that are also the boundaries of the house plots. The bones are found from the oldest phase up to the youngest. It can therefore be presumed that the preparation of furs, and their trade, existed from the foundation of Birka in the middle of the eighth century until the town was deserted in the late tenth century. The processing of furs seems not to have taken place in specific houses or workshops, but most probably was dispersed in the 'ordinary' households of Birka.

Identified species, body parts and interpretation of the bone finds

Species

The most common species found at Birka are fox, squirrel and pine marten; rarer species are brown bear, beaver, wolf, lynx, ermine, badger, otter, polecat and wolverine. Finds of specific body parts from mountain hare, seal and goat (animals not always connected with furs) suggest that it was not the meat but only the furs or hides of these animals that reached Birka (See Table 1).

Bodyparts

The only parts of fox, squirrel, marten, hare and all the minor mammals found are the bones of the paws. These comprise four or five metapodials and 12–15 phalanges, including the claws. From squirrel we sometimes also find bones from the tail and parts of the lower hind-leg or fore-leg. Remains of larger mammals, like bear and wolf, are usually the third phalanges (the claws). The rest of the bones were probably left where the animal was skinned, so we should not expect to find them in the town area. In the town of Sigtuna there are also some examples of animal skulls with cut marks, even from cat (Hårding 1991: 106), but at Birka the skulls and also skinned cats are missing. The seal bones found are mostly phalanges, which tells us that none or very little seal meat was

Table 8.1 Identified fur-bearing species at Birka

	In the Black Earth	Also in graves
Red fox (*Vulpes vulpes*)	✓	✓
Pine marten (*Martes martes*)	✓	✓
Red squirrel (*Sciurus vulgaris*)	✓	✓
Brown bear (*Ursus arctos*)	✓	✓
Wolverine (*Gulo gulo*)	✓	
Wolf (*Canis lupus*)	✓	
Lynx (*Lynx lynx*)	✓	✓
Badger (*Meles meles*)	✓	
Beaver (*Castor fiber*)	✓	✓
Otter (*Lutra lutra*)	✓	
Ermine (*Mustela erminea*)	✓	
Polecat (*Mustela putoris*)	✓	
Mountain hare (*Lepus timidus*)	✓	
Seal (*Phoca species*)	✓	
Hides	✓	
Goat (*Capra hircus*)	✓	

consumed and only the skin was imported. The goat hides that came to Birka still had the feet and horns attached. The horn cores from goat were cut off in quite a different way from cores of cow and sheep; complete feet of goat have also been found in situ. This type of bias in body parts is a clear indication that goat hides were valued more highly than the meat of the goat. Similar ways of handling hides have also been observed on other sites in Europe (Serjeantson 1989: 136).

2. Bones of two pine-marten paws, from the Black Earth, Birka (photo: T. Jakobsson, RAÄ/Birka).

LEATHER AND FUR

Methods of processing furs in Birka (a preliminary hypothesis)
The large amount of bone from fur-bearing animals indicates a huge trade in furs to and from Birka. Every year thousands of skins arrived and were sold, clearly indicating a well organized hunting system and trade routes from the place of hunting. The animals were hunted mostly in northern Sweden, in the great forests, perhaps by the Saami (Lapps) or other people specialised in hunting. The wolverine, for example, is today only found in Lapland, the most northern part of Sweden. No doubt the wolverine, like other mammals that are rare nowadays, was more common in other parts of Sweden during the Viking period, but hunting them must have been difficult even then.

Winter or early spring is the best time of the year for hunting, when the fur on the animal is at its thickest and therefore most valuable. After the animal had been killed or trapped the hunter skinned it using an ordinary sharp knife, most likely directly in the forest. Only the paws or, as with squirrels, the tail (including the bones) were left attached to the skin. The rest of the animal was abandoned in the forest. Perhaps it was easier to dry or to stretch out the fur, using sticks, if the paws were still attached. In the spring or late winter the hunter would sell the skins in bundles to special skin traders or he might go directly to Birka.

In Birka the processor (furrier) would prepare the skin by cutting off the paws and then throwing them away, where a thousand years later we find them with other rubbish. The skin was then cured and might be made into fur garments on the spot. In some graves fur-trimmed collars or caps have been found, which the people in Birka wore during the cold part of the year. Other furs from larger mammals were cured and used as they were. Goat hides were tanned into leather. Probably cow hides also reached Birka, but no such remains of leather or hide have been found on this dry site.

Many of the furs, processed or not, were exported to sites in Sweden and abroad. The long-distance trade is confirmed by precious imported artefacts and historical records. The imported artefacts from Russia, the Khazar region, Byzantium and Arabia may be seen as payments for furs sold.

Conclusions

From its foundation in the mid 750s until its desertion in the late tenth century, Birka was a centre of great importance for trade and for processing furs which came from the whole of northern Sweden. The

furs were exported to distant areas via Russia to the Near East and perhaps even further away. The value of a big fur (eg. bearskin) was considerable and only a few people could afford to own or to be buried with one. The production of fur garments was probably carried out in ordinary households all over the town of Birka. The most prized (or available) furs were of fox, marten and squirrel. The most common furs found in inhumation graves on Birka are beaver fur trimmings, although beaver, together with other larger fur-bearing animals, are quite rare in the bone material from the Black Earth.

The final analysis of the well preserved bone material from the latest excavations in Birka has just begun, so more precise and extensive results will soon be available. Perhaps we shall then understand more about the extensive trade in skins, hides and furs that took place in Sweden, and especially at Birka, during the Viking period.

References

Ågren, T. (1993) *Pälshår från Birka: En Undersökning av Hårrester i Svepelektronmikroskop*, unpublished, 80-poängsuppsats i laborativ arkeologi, Stockholms universitet, Stockholm.

Åkerman, J. (1969) *Jägaren och Bytet efter Skottet*, Stockholm.

Ambrosiani, B. (1991) *Birka on the Island Björkö*, Board of National Antiquities, Stockholm.

Ambrosiani, B. (1992) 'Excavations at Birka 1990–94: setting up the project', in *Birka Studies I, Investigations in the Black Earth*, B. Ambrosiani and H. Clarke (eds), RAÄ-SHMM, Stockholm.

Ambrosiani, B. and Eriksson, B. G. (1991) *Birka, Vikingastaden volym 1*, Helsingborg.

Ambrosiani, B. and Eriksson, B. G. (1994) *Birka, Vikingastaden volym 4*, Helsingborg.

Ambrosiani, B., Arrhenius, B., Danielsson, K., Kyhlberg, O. and Werner, G. (1973) *Svarta Jordens Hamnområde. Arkeologisk Undersökning 1970–1971*, Riksantikvarieämbetet Rapport C1. Stockholm.

Clarke, H. and Ambrosiani, B. (1993) *Vikingastäder*, Helsingborg.

Ericson, P. G. P., Iregren, E., and Vretemark, M. (1988) 'Animal exploitation at Birka', *Fornvännen 83*, Stockholm.

Geijer, A. (1938) *Birka III. Die Textilfunde aus den Gräbern*, Uppsala.

Hagberg, U. E. (1967) *Skedemosse. Studier i ettöländskt offerfynd från järnåldern*, Uppsala.

Hårding B. (1991) 'Vad benen berättar', in *Makt och Människor i Kungens Sigtuna Sigtunagrävningen 1988–90*, S. Tesch (ed.), Sigtuna Museer.

Hägg, I. (1974) *Kvinnodräkten i Birka*. Livplaggens rekonstruktion på grundval av det arkeologiska materialet. Aun 2. Archaeological Studies Uppsala University of North European Archaeology. Uppsala.

Hägg, I. (1986) 'Die Tracht', *Birka II:2. Systematische Analysen der Gräberfunde*, Stockholm.

Jonsson, L. (1989) 'Massfångst av sjäfågel och pälsdjursjakt', in *Avstamp – för en ny Sigtunaforskning. 18 forskare om Sigtuna*. Kommitén för Sigtunaforskning. Sigtuna Museer.

Petré, B. (1980) Björnfällen i begravningsritualen – statusobjekt speglande regional skinnhandel, *Fornvännen 75*, Stockholm.

Serjeantsson, D. (1989) 'Animal remains and the tanning trade' in *Diet and Crafts in Towns*, D. Serjeantson and T. Waldron (eds), BAR British series 199, 129–46.

Steckzén, B. (1964) *Birkarlar och Lappar. En Studie i Birkarleväsendets, Lappbefolkningens och Skinnhandels Historia*, KVHAA, Stockholm.

Stolpe, H. (1872) *Naturhistoriska och Arkeologiska Undersökningar på Björkö i Mälaren I*, Öfversigt af Kongliga Vetenskaps Akademins Förhandlingar 1, Stockholm, 3–27.

Stolpe, H. (1873) *Naturhistoriska och Arkeologiska Undersökningar på Björkö i Mälaren II*, Öfversigt af Kongliga Vetenskaps Akademins Förhandlingar 5, Stockholm, 3–79.

Wigh, B. (1993) 'Femtio tunnor gröfre ben och 80 lådor mindre ben', *Populär Arkeologi*, 1, 34–6.

Wigh, B. (1995) 'The Animals Bones from Birka 1991', in *Birka Studies II, Excavations in the Black Earth 1990*, B. Ambrosiani and H. Clarke (eds), RAÄ-SHMM, Stockholm, 88–9.

◆8◆

The British Beaver – Fur, Fact and Fantasy

James A. Spriggs

To most of us the beaver is very much a New World animal and nowadays this is, to a large extent, true. But there was a time when the beaver (or the visual impact of its curious life-style) was not unusual in many parts of Britain, and was considered a useful and valuable resource. In retrospect it is tempting to suggest that, were it not for the British penchant for beaver fur, the British colony of Canada might never have existed. The New World beaver, *Castor canadensis*, is certainly no stranger to our shores, hundreds of thousands of pelts at one time forming a major part of the cargos of the London-based Hudson's Bay Company merchant fleet. The European beaver, *Castor fiber*, although not totally extinct, had become so reduced in numbers to render organ-

1. Canadian beavers.

ised trapping uneconomical and had certainly not been seen in the British Isles for at least 800 years.

But what caused this seemingly insatiable appetite for beaver and what market could afford the expense of this, one of the earliest examples of transatlantic trade? The answer is simple; it was that ultimate fashion accessory, that barometer of style, status and wealth – the hat. But this is modern history and to find out about the British beaver and its fate one must look back several thousand years and use the scraps of evidence that archaeology can provide.

The beaver in pre-history

As the ice-caps receded around 10,300 years ago, the open vegetation in what was to become Britain gave way to forest in many parts, and became attractive to many kinds of forest-loving beast that crossed the land-bridge from Europe before rising sea-levels formed the English Channel about 8,500 years ago (Davis 1987: 174). Many of these beasts, including the beaver, were eventually hunted out of existence; reindeer, aurochs and wild boar were hunted as a source of food and raw materials for the manufacture of artefacts or pressed into domestication to become the precursors of some our modern farm animals. Others, such as the wolf, wild cat and bear were primarily hunted because they were a menace and danger to humans and their stock, but also provided essential pelts and furs. The beaver, pine marten and other small fur-bearing animals were trapped for the same reason, but the beaver may also have had other uses.

It has been suggested that, from the early Mesolithic period (c. 10,500 years ago), the damming of streams and small rivers by the beaver created lakes that would be attractive to hunters after waterfowl (Coles and Orme 1983: 95–103). As the lakes silted up, watermeadows would form, which would attract grazing animals such as deer and aurochs – and wolves and hunters. Clearings in the forest would be formed by the natural coppicing (wood-chewing) activities of beaver, clearings which, being close to water, would make good sites for human settlements. There would be a ready source of pre-cut and dried firewood and light building materials to hand, also courtesy of the beavers (Coles 1992).

A number of archaeological sites have yielded examples of beaver-chewed wood, recognisable by the distinctive parallel tooth marks on the cut ends and lateral tooth marks up the stems where the bark

2. Bronze Age beaver-chewed wood from Caldicot, South Wales (courtesy of Glamorgan Gwent Archaeological Trust; photo: York Archaeological Trust).

and underlying cambium have been stripped away to eat. These finds come mainly from classic wetland sites, such as Starr Carr, Yorkshire; Glastonbury and the Somerset Levels; Caldicot, South Wales; and (most recently) Skipsea, East Yorkshire. This material dates from the early Mesolithic to late Bronze Age and is normally found in association with man-made structures; the Starr Carr, Yorkshire and Baker, Somerset platforms for example. Here is evidence of beaver-felled wood being collected and utilised by humans for their constructions. Beaver dams as such have not yet been identified archaeologically, though there are suggestions that finds of ditches, chewed wood and beaver bones at Thatcham and Newbury, both on the River Kennet, may be natural beaver activity leading to the formation of the local peats (Coles 1992). It has also been suggested that the raised peats, now being so heavily exploited at Thorne Moors near Doncaster, were formed after the extensive felling of the forest in the early Bronze Age, the beaver possibly being one of the natural agencies involved (Johnson and Roworth 1994: 66).

Similarly, archaeofaunal remains of beaver are not uncommon but many are 'chance' finds and are not readily dateable or from secure contexts, although coming from classic wetland locations. One particularly interesting occurrence was the discovery of beaver incisors in the

burial chamber of the great Neolithic mound of Duggleby Howe on the Yorkshire Wolds, excavated in 1890. Amongst a number of inhumation and cremation burials were found tools and implements made of boar's tusks, red deer antlers and, most significantly, two beaver's teeth. These were identified as chisels, as they appeared to have been ground to form a cutting edge, and (possibly) chipped through use (Kinnes *et al.* 1983: 83–108).

Beavers during the Roman Period

It has not been possible to find any references to archaeological evidence for the exploitation of beavers during the Romano–British period, although this must surely have occurred. With the rapid spread of well organised agriculture, the beavers' traditional habitats would have been destroyed, and surviving beavers would have become marginalised. The wearing of furs was certainly not fashionable amongst the Romanised population (Howard-Johnston, this volume), but the indigenous British and Celts would certainly still have been taking beaver for their fur. In AD301, however, the emperor Diocletian issued an edict controlling the prices of certain commodities as an anti-inflationary measure, and includes in the tariff a type of cape or cloak called the *Byrrus Britannicus*. Another reference to this garment (although not in a British context) describes it as a *Byrrus castalinus*, which may be descriptive of a beaver-skin cloak (Wild 1963: 193–202).

The Roman Empire also supported a huge market in perfumes, oils and drugs derived from animals, and the 'castoreum' produced from the scent glands of beavers was a much prized commodity. Pliny the Elder in his *Naturalis Historia*, written in AD77 (Rackham 1979), says that beavers of the Black Sea region are hunted for *castoreum*, and also that their fur is 'softer than down', implying that the fur was much prized. The principal use of *castoreum* was as a drug and cure-all; a use that continued well into the nineteenth century (Wilson 1858: 1–40) and probably into our own. *Castoreum* contains salycilic acid, a natural form of aspirin, and does, indeed, have pharmaceutical qualities. It was employed, according to Herodotus, in the treatment of uterine diseases and Pliny (amongst other classical writers) describes its use to induce sleep, and in the treatment of mania, epilepsy, vertigo, tremors, spasms, dyspepsia, hiccups, palsy and a large number of other complaints (Wilson 1858).

Saxon and Celtic beavers

Archaeology again provides evidence of beaver in the early medieval period, but not in the form of beaver-chewed wood. This is a strong indication that their habitats were already reduced and marginalised to wild areas at some distance from human habitation and agriculture, even taking into account the vagaries of archaeological selectivity. But the wearing of furs must have been in fashion again as their bones turn up in archaeological contexts. In York, for example, four bones, possibly from the same individual, were found amongst general rubbish within the eighth- to ninth-century pallisaded settlement of Eoforwic (O'Connor 1991: 256) and a skull bearing knife marks from skinning was found in late Saxon levels at Ramsbury in Wiltshire (Haslam *et al.* 1980: 1–68), good evidence for the exploitation of beaver for its pelt or meat.

That the beaver was already becoming scarce though, even in the wilds of Wales, is reflected in the Code of Welsh Laws made in about AD940 by King Howel Dha, who lays down the value of different types of fur from which the borders of the king's garments are made. The price of beaver is fixed at 120 pence, whereas marten was only 24 pence, and wolf, fox and otter 8 pence each (Harting 1880: 33–60).

The Saxon period also provides us with one of the only examples of beaver fur being found in an archaeological context. This was the discovery of patches of beaver hair in contact with the remains of the wooden lyre in the burial chamber of the Sutton Hoo ship burial (Stoves 1983: 723–4). This seventh-century beaver-skin had been used, it has been suggested, to form a bag to contain the lyre (Bruce-Mitford 1983) although there is a temptation to suggest other more appropriate uses for the pelt and the connection between lyre and fur being coincidental. However, the presence of beaver in such a high status context must signify its value and, perhaps, rarity. Indeed, a beaver's incisor mounted in gold as a pendant was found during excavations at Wigber Low, Derbyshire, in 1869. Although from a disturbed context, it is thought to relate to a group of seventh-century burials at the site (Agar 1983, 73–83).

The medieval beaver

By the Middle Ages, the British beaver is already missing from the archaeological record and was most probably extinct in England. There are, however, two medieval references to the presence of beaver in

Scotland. The earlier is during the reign of King David (1124–1153), where it is listed with other fur-bearers in *Assisa Regis David de Tolloneis* (Wilson 1858). This sets out the export duties to be paid for a timmer (40) of furs, which, as in the Welsh Laws of Howel Dha, varied according to species – demonstrating the continued economic viability of beaver hunting or trapping. The later Scottish reference to beaver is in the Ayr Manuscript, drawn up during the reign of Robert the Bruce (1306–1329) (Ritchie 1920). However, this list also contains sable, which has never been indigenous to Britain, so that the beaver skins referred to may have been imported for re-export.

The continued existence of beaver in Wales is witnessed by the curious account left by Geraldus Cambrensis, Archdeacon of Brecon, who, in the company of Baldwin, Archbishop of Canterbury, undertook a journey through Wales in about 1190. He prefixes a vivid account of its habits, apparently derived in some part from his own observation, with the information that the River Teifi is the only place that beaver may still be found. He also says that he has been told that 'there is also a stream in Scotland where they still live' (Harting 1880: 34). This, then, is the last firm reference we have to the continued existence of the native British beaver, which, with the exception of the wild boar and the wolf, is actually one of the most recent extinctions amongst Britain's wild fauna.

Also contained in Geraldus' description of the beaver, is a repetition of a fable concerning the hunting of beaver for the sake of its testicles, which were (erroneously) thought to contain *castoreum*. The castor glands are actually situated in the abdomen and open into the urethra. The secretions from these glands, combined with urine, form *castoreum* which, as we have seen, was known to have medicinal properties. Geraldus says:

> In Eastern countries when the beaver finds it cannot evade the dogs which are following it by its scent, it saves itself by self mutilation. By some natural instinct, it knows which part of its body the hunter really wants. The creature castrates itself before the hunter's eyes, and throws its testicles down. It is because of this act of self castration that it is called *Castor* in Latin. If a beaver which has already lost its testicles is hard pressed a second time by the hounds, it rushes to the top of a hillock, cocks up one of its hind legs and shows the hunter that the organs he is after have already been cut off. (Thorpe 1978: 176)

This is, in fact, an ancient and popular fable related by (amongst others) Aesop, Aristotle, Solinus, Juvenal, as well as Pliny the Elder. The

3. The ancient beaver hunt legend, as represented in a thirteenth-century English bestiary (MS Bodl. 764, fo. 14r, The Bodleian Library, Oxford).

tale rises from a fairly obvious mistranslation of the name Castor, which is either from the Greek *gastor* from 'its prominent swaggy belly' (Browne 1646: 112–13) or from the word *castreum* coming, via the Greek, from the Hebrew word for musk (Thorpe 1978: 174–7). Either way, this most unlikely tale was absorbed into various pious books of beasts (bestiaries) of the Middle Ages, where beavers symbolised men who cast away lust to serve God more perfectly (Kightly 1988: 82).

A further interesting fact Geraldus gives us is that beaver, 'are very common in Germany and the Arctic regions [i.e. Scandinavia] and there, in times of fasting, the great leaders of the church eat their tails instead of fish'. The church establishment in England need not have gone to the expense of shriving themselves on beaver's tails during Lent, since here porpoise and barnacle goose were classed as fish. As late as the 1460s, however, the Clerk of the Kitchen to Humphrey, Duke of Clarence, in his book on cooking and kitchen management, lists beaver tails as suitable lenten fare. Topsell in the 1658 edition of his *Four Footed Beasts* gives a recipe for beaver tails as used by 'Lothariangians and Savoyans' (Dent 1974: 51). One can only speculate that, in both cases, the tails must have been imported from the Continent, and were a by-product of the fur trade – as is the case in Scandinavia today, where beaver tails are still considered a delicacy.

The foreign fur trade

The wearing of furs for warmth and as expressions of fashion and status in medieval Britain gave rise to the establishment of a vigorous overseas trade in the pelts of a variety of animals; beaver, along with sable and ermine, was always one of the more expensive. Trade with the Baltic ports in pelts extracted from Scandinavia was controlled by the Hanseatic League and an analysis of the customs accounts of the Port of London for a large part of the medieval period gives a rough indication of the volume of beaver (and other peltry) entering the country by that route (Veale 1966). As the fur trade with Scandinavia diminished, new sources were sought and the forming of the British-owned Muscovy Company in 1555 opened up new sources in Russia and effectively broke the Hanseatic trading monopoly in furs (Rich 1955). Beaver was the principle fur obtained from this new source and was available in quantity, but continual trading difficulties with the Tsars spurred adventurous English voyagers elsewhere.

The unceasing search for a northwest passage to Cathay brought British merchant adventurers into contact with Indians in northern Canada. The great wealth of fur-bearing skins, including beaver, that the Indians offered for barter eventually brought about the founding of the Hudsons

4. The coat of arms of the Hudsons Bay Company.

Bay Company under the patronage of Prince Rupert in 1670 (Rich 1958). By this time, the wearing of furs was no longer fashionable except on formal occasions, and beaver was now exclusively employed in the production of that ultimate expression of style and fashion – the felt hat. Felting for hats has an ancestry going back perhaps to the Saxon period (Beck 1886) and beaver felt was always considered the lightest, strongest and most waterproof, and was certainly the preferred 'quality' material. Beaver's fur is made up of a mixture of coarse guard hairs and a great number of exceedingly fine and closely-waved fur fibres of 8–10 micrometres mean diameter and about 10mm long (Wildman 1954: 165). It is the smoothness of the fibres allied with the fine crimp that makes this fur so suitable for felting, although the coarser guard hairs must be removed first.

Archaeological finds of medieval felt are rare and of considerable interest (Walton-Rogers 1993: 24–6) but, to our knowledge, no beaver felt has yet been identified. However, there are many literary allusions to beaver hats. Henry Chaucer, in the late fourteenth century, refers to the merchant in his Canterbury Tales as wearing upon his head a 'Flaundryssh bever hat' (Coghill 1951). Phillip Stubbes, a noted Puritan, considered the asking price of 40s. in 1583 as an 'outrageous price for a beaver hat.' Samuel Pepys noted in his diary for 1661 that a beaver hat had cost him 45s. and that, on a wet evening ride in April 1662 he says 'I

5. Landscape modification: a modern beaver dam in Tierra del Fuego (photo: A. Crawshaw).

was nothing troubled by the badness of my hat which I borrowed to save my beaver' (Clark 1982).

The trade in beaver continued to serve the hatting industry well into the nineteenth century when, in about 1840, the fashion in high hats demanded a high gloss effect that could only be achieved through the use of silk and this 'new technology' spelled the virtual end to beaver fur importation. Of the beaver itself, the story may not be entirely over. There have been several attempts at introductions into the wild, most successfully perhaps in the early 1870s by the Marquis of Bute into Rothesay on the Isle of Bute in Scotland (Harting 1880: 33–60). A little earlier, a similar attempt was made at Sotherley Park near Wangford, Suffolk, but the damage caused by their dam-building was considered unacceptable, and the beavers were killed in 1872. But there is still hope. Scottish Natural Heritage have serious plans to re-introduce the beaver into the Highlands (Kitchener and Conroy 1996). Maybe the European beaver may once again reclaim its rightful place in the otherwise impoverished British natural fauna. And why not? In recent years *Castor fiber* has been introduced to almost a hundred sites in continental Europe, and now supports new industries in fur and meat.

Acknowledgements

Thanks are due to all those friends and colleagues who so willingly provided information and references, and to Penelope Rogers, Andrew Kitchener and Arthur MacGregor for making many valuable comments on the text.

References

Agar, B. (1983) 'Metal, bone and glass' in *Wigber Low, Derbyshire: a Bronze Age and Anglian Burial Site in the White Peak*, J. Collis, University of Sheffield, 73–83, 101–2.
Beck, S. W. (1886) *The Draper's Dictionary*, London.
Browne, T. (1646) *Pseudoxia Epidemica or Enquiries into very many received Tenets and commonly presumed Truths*, London.
Bruce-Mitford, R. L. J. (1983) *Sutton Hoo*, 3, ii, London.
Clark, F. (1982) *Hats*, Costume Accessories Series, London.
Coghill, N. (1951) *The Canterbury Tales*, Harmondsworth.
Coles, B. (1992) 'Further thoughts on the impact of beaver on temperate landscapes', in

Alluvial Archaeology in Britain, S. Needham and M. G. Macklin (eds), Oxbow monograph 27, Oxford, 93-99.

Coles, J. M. and Orme, B. J. (1983) 'Homo sapiens or Castor fiber?', *Antiquity* **57**, 95-102.

Davis, S. J. (1987) *The Archaeology of Animals*, London,

Dent, A. (1974) *Lost Beasts of Britain*, London,

Harting, J. E. (1880) *British Animals Extinct Within Historic Times*, London,

Haslam, J., Biek, L. and Tylecote, R. F. (1980) 'A Middle Saxon iron smelting site at Ramsbury, Wiltshire', *Journal of Medieval Archaeology* **24**, 1-68.

Johnson, B. R. and Roworth, P. C. (1994) 'The Revival of Thorne Moors, a unique lowland wilderness in Yorkshire', *Yorkshire Philosophical Society Annual Report*.

Kightly, C. (1988) *A Mirror of Medieval Wales*, Welsh Historic Monuments, Cardiff.

Kinnes, I., Schadla-Hall T., Chadwick, P. and Dean, P. (1983) 'Duggleby Howe Reconsidered', *Archaeological Journal* **140**, 83-108.

Kitchener, A. C. and Conroy, J. (1996) 'The history of the beaver in Scotland and the case for its reintroduction', *British Wildlife* **7**(3), 151-61.

O'Connor, T. P. (1991) 'Bones from 46-54 Fishergate', *Archaeology of York* **15**(4), 256.

Rackham, A. (trans.) (1979) *Pliny: Natural History* 8, xlv, London, 78-9.

Rich, E. E. (1955) *Russia and the Colonial Fur Trade*, London.

Rich, E. E. (1958) *The Hudson Bay Company 1670-1870*, London.

Ritchie, J. (1920) *The influence of man on animal life in Scotland*, Cambridge.

Stoves, J. L. (1983) 'Examination of Hairs from the Sutton Hoo Musical Instrument', in *Sutton Hoo* 3, ii, R. L. J. Bruce-Mitford, London, 723-5.

Thorpe, L. (1978) *The Journey Through Wales* 2, Harmondsworth, 174-7.

Veale, E. M. (1966) *The English Fur Trade in the Later Middle Ages*, Oxford.

Walton-Rogers, P. (1993) *Textiles from the City of Lincoln 1972-1989*, City of Lincoln Archaeology Unit.

Wild, J. P. (1963) 'The Byrrus Britannicus', *Antiquity* **37**, 193-202.

Wildman, A. B. (1954) *Microscopy of Animal Fibres*, Wool Industries Research Association, Leeds.

Wilson, C. (1858) 'Notes on the prior existance of Castor fiber in Scotland, with its ancient and present distribution in Europe, and of the use of castoreum', *Edinburgh New Philosophical Journal*, New Series **8**, 1-40.